IMAGES
of America

FORTY ACRES

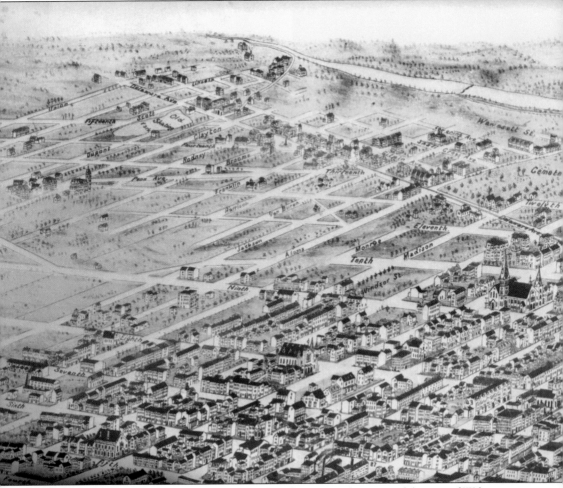

The Forty Acres neighborhood is located within the west-end section of the city of Wilmington, Delaware. This compact neighborhood, with its mixed-use commercial and residential buildings, is often compared to an independent village within the city. This detail, taken from an 1874 map of Wilmington, Delaware, illustrates the Forty Acres area at the upper part of the image, while a portion of Greater Wilmington is visible in the lower part of the picture. (Courtesy of the Delaware Historical Society.)

ON THE COVER: Pictured is an interior scene of Cappeau's Drug Store. This popular neighborhood hangout was once located on the corner of Delaware Avenue and DuPont Street. From left to right, (sitting) Ben Beyea, Dan Dallett, Elise Pruckett, and Jo Bradford; (standing) Helen Kitchell, Peggy Rankin, and Charles S. Kelly enjoy their soda fountain drinks. (Courtesy of the Delaware Historical Society.)

IMAGES
of America

FORTY ACRES

Kara A. Briggs Green

ARCADIA
PUBLISHING

Published by Arcadia Publishing
Charleston, South Carolina

Printed in the United States of America

Library of Congress Catalog Card Number: 2008933019

For all general information contact Arcadia Publishing at:
Telephone 843-853-2070
Fax 843-853-0044
E-mail sales@arcadiapublishing.com
For customer service and orders:
Toll-Free 1-888-313-2665

Visit us on the Internet at www.arcadiapublishing.com

For Liam and Conor
as well as the Briggs, McKinney, Fitzharris, and Kaiser families

CONTENTS

ACKNOWLEDGMENTS

I wish to thank Cissy Briggs, Bill Briggs, state representative Gerald L. Brady, Lauren Cardillo, George Constantinou, John Walter Constantinou, Ann Faulkner, Cecilia Gallagher, Edie Guthrie, John Flaherty, Robert Keller, Ober R. Kline, August and Terry Muzzi, Damian Muzzi, Paul M. Schofield Sr., Tracey and Paul M. Schofield Esq., Jackie Walls, and so many others from the Forty Acres community who have shared their photographs and experiences of this unique neighborhood. I also wish to thank Dr. Connie Cooper and Ellen Rendle of the Delaware Historical Society, Donn Devine of the Catholic Diocese of Wilmington Archives, Chief Willie J. Patrick and John Porter of the Wilmington Fire Department, the Water Witch: Fire Station No. 5 Archives, and Jon Williams of the Hagley Library for graciously providing a number of images appearing in this book.

I am especially indebted to Mr. and Mrs. William J. Briggs III, Erin Marie Kathleen Briggs, Margaret Amy Salter, Timothy Mullin, and Rebecca Sheppard. Without your support, this project would not have been possible.

INTRODUCTION

Nestled in the west end of Wilmington, the neighborhood of Forty Acres developed during the 19th century from a 40-acre parcel purchase of farmland by Joshua T. Heald. With the assistance of the Wilmington City Railway Company, this entrepreneur introduced streetcar rail lines into Wilmington in 1864. This event prompted the development of the rural location into an urban residential and commercial neighborhood known as Forty Acres. This type of development—the sale of the old family farm in order to make way for the modern suburb—is not new. However, what was different in this case was the purchase and development of farmland into an urban area with close proximity to planned transportation lines. Forty Acres may be considered one of Wilmington's first suburbs. The neighborhood of Forty Acres set the precedent for future Wilmington streetcar suburbs such as Elsmere, Price Run, and Eastlake, all of which were developed by J. T. Heald.

Today Forty Acres is an urban neighborhood located north of Delaware Avenue, south of Riddle Avenue, east of Union Street, and west of DuPont Street. Before Forty Acres existed as an urban neighborhood, with planned streets and a transportation line, a number of milling industries were located in and around the area. Over time, other industries such as brewing, printing, and the trolley car and bus barns supplied mass employment to those of the Forty Acres area. As the Wilmington City Railway Company trolley line opened a means of transportation for Wilmingtonians, enabling travel to and from Forty Acres and downtown Wilmington, development of the neighborhood progressed. These industries, combined with the Wilmington City Railway Company and carbarns, provided jobs and economic stability for many families of Forty Acres. When the Wilmington City Railway Company advanced their technologies to include electric trolley cars, the prototypes were first tested in Forty Acres. Once deemed successful, other electric cars were introduced to all of the city's trolley routes. The further advancement of technology brought a new experiment to Forty Acres carbarns in the form of busses. Each change in technology brought an evolution in existing jobs as well as the demand for new ones. The men of the Forty Acres, who once worked carbarn jobs as blacksmiths shoeing horses, now needed mechanical skills.

Wilmington is a city composed of a variety of neighborhoods defined by churches, parks, and a wide range of ethnicities. It is often described as a city of ethnic neighborhoods each located within specific locations of the city. As many other Wilmington neighborhoods have ethnic associations, so too does Forty Acres. Many Irish Wilmingtonians claim roots in this area. By 1883, about 150 households made up the Forty Acres neighborhood. Though slightly over half the residents were American-born, the community showed a much higher percentage of foreign-born than the rest of Wilmington. Nearly one-third of the people living in Forty Acres were Irish. By this time, the neighborhood was recognized as working-class, surrounded by neighborhoods of middle-class and affluent households. Many of the Forty Acres families were generational, and so the neighborhood continued in popularity well into the 20th century. Today most of Wilmington's original ethnic neighborhoods no longer contain a high number of immigrants, but rather house their descendants. These neighborhoods continue to exist as local communities, and the local community continues to be the prime context for day-to-day life. Traditional communities persist for very traditional reasons that keep people together: historic loyalties; regional concentrations;

and class, ethnic, racial, or religious affinities. These neighborhoods fill a need for cultural roots and identity. The more uniform our world becomes, the more people seek to anchor themselves within a community. Today, despite a true American melting pot of residents, Forty Acres is still perceived as an Irish neighborhood. The residents of this compact city neighborhood understand that what they have is special. They live in an area that is pedestrian friendly, has a variety of shops and services within walking distance, and is a main stop on the city's public bus system. It is a neighborhood where residents look out for one another and care about the condition and upkeep of their community.

A neighborhood is a place of physical structures and institutions within which and with which people exist. Examples of these physical buildings, social areas, and institutions exist throughout Forty Acres. In fact, many of these structures have become landmarks in their own right and therefore are associated with the community of Forty Acres. Among these local landmark buildings is the Gothic Revival St. Ann's Roman Catholic Church, built of Brandywine stone. The church and its school mean so much more to local and neighborhood residents than beautiful buildings because of the spirit of service and community that the buildings represent. These buildings are important because the foundation of St. Ann's is not only composed of strong building materials but also of a strong human element that facilitates the care and service of not only the St. Ann's community, but the entire community as well. Another building associated with the community of Forty Acres is Gallucio's Restaurant and Pub. This structure is the last remaining building of the 1865, three-acre John Hartmann and John Fehrenbach Brewery complex that at one time housed approximately 10 buildings. Gallucio's advertises itself as "A Neighborhood Restaurant & Pub" and hosts a variety of events. Another local landmark building is the oldest continuously operating firehouse in the city of Wilmington, known as the Water Witch Fire Engine Company No. 5. This fire station has always been a source of pride in the neighborhood. Last, but certainly not least, of the public structures associated with the Forty Acres neighborhood is the pub known as Kelly's Logan House. This popular city bar and nightspot, whose ownership has passed through generations of the Kelly family since it was first purchased by family patriarch John D. Kelly II in 1889, was first constructed in 1865 by William Wharton Jr. as a hotel. Generations of Kelly family members have promoted this neighborhood bar as a center for Irish social and cultural life. These buildings—the church, the restaurant, the firehouse, and the pub—are elements of the neighborhood and are part of its fabric and community.

Examined separately or as a whole, these buildings constitute a place and exemplify the unique character of that place. The neighborhood of Forty Acres maintains certain characteristics that differentiate this community from other areas of the city of Wilmington. Peppered amongst the residential structures of the neighborhood are a church, a school, various retail shops, diners, a social club, a nursing home, a funeral home, a grocery store, and a gas station. Having these commercial and public-use properties interspersed with residential structures is convenient to residents and results in regular activity on neighborhood walks. For example, a purchase of staples like bread or milk requires only a two-block walk rather than a 5–10-minute car ride to the store. On that walk to the store, opportunities abound for any number of interactions between neighbors and promotion of community.

Forty Acres is celebrated for its picturesque charm, its sense of community, and its feeling of home. It is a place where residents take ownership of the neighborhood and work together to make it a better place for the greater good of the community. As one resident, Ober R. Kline, said of the neighborhood, "Forty Acres is a community where neighbors care for one another and look out for one another, share with one another, and help one another. The people that live here and are the real neighbors—you don't have to ask if you're juggling with a mass of packages while fumbling for the keys to get into your house or if you see somebody who is struggling to try and get their car unstuck. They don't have to ask you to come and help; you automatically go and say 'let's give you a hand.'" In Forty Acres, the bank teller might be your neighbor from around the corner. As you leave the bank, you may say "have a nice day" to the guard who is the grandfather of a girl with whom you attended school. You may enter the neighborhood luncheonette and sit

next to the woman who was in the pew just ahead of you at church last Sunday. Forty Acres is a neighborhood community with innumerable relationships connecting people and places across the expanse of time.

One

FROM FARM TO STREETCAR SUBURB

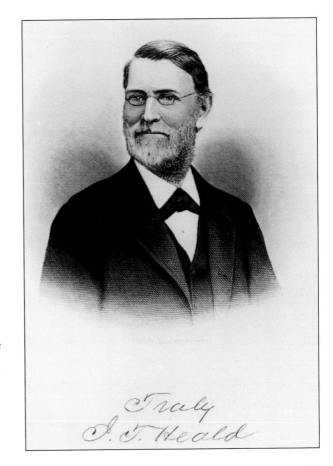

A perceptive real estate entrepreneur, J. T. Heald recognized the expansion of the Wilmington city limits in 1861 to Union Street as a development opportunity. He entered into an agreement with Joseph S. Lovering, owner of the property known as Shallcross Farm, for the purpose of plotting and selling building lots. Heald purchased 40 acres of farmland. It is through this parcel purchase that the neighborhood received its name of "Forty Acres." (Courtesy of Hagley Museum and Library.)

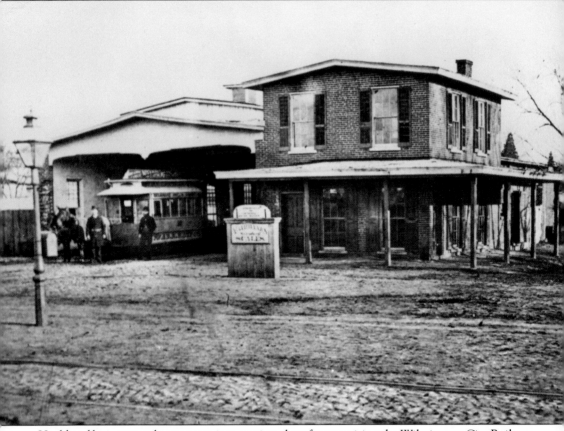

Heald and his partners began to set into motion plans for organizing the Wilmington City Railway Company (WCRC). The WCRC opened for operation with 7 horse-drawn trolley cars and 35 horses in 1864. This photograph of the carbarn was taken September 8, 1883. The carbarn site was nestled in the city block bordered by Delaware and Gilpin Avenues and Clayton and DuPont Streets. In the beginning, the carbarn complex housed a carbarn, waiting room, stables, and a blacksmith shop. (Courtesy of Hagley Museum and Library.)

In October 1864, the streetcar line extended tracks a little over 1 mile west from Delaware Avenue and DuPont Street to Rising Sun Lane. Soon thereafter, the carbarn became additionally known as the Middle Depot, named for its function at the middle of the line from downtown Wilmington to Rising Sun Lane. This c. 1880 print from a glass-plate negative details the intersection of Delaware Avenue and North Union Street. The view, taken from the northwest corner of Delaware Avenue, illustrates the hustle and bustle of these cross streets to be just as busy then—albeit with different vehicles—as today. (Courtesy of Avenue Wines and Spirits.)

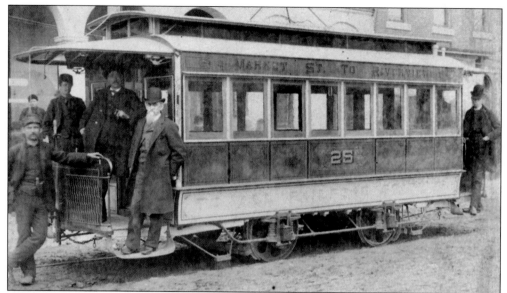

Separate images show the No. 23 electric trolley situated outside the Ebbitt Theater at Tenth and Market Streets and the No. 23 trolley on Delaware Avenue with an unidentified driver standing alongside it. The WCRC and carbarns provided jobs and economic stability for many families of Forty Acres. When the WCRC advanced in technology, the prototypes were tested in Forty Acres first. When the WCRC decided to convert horse-drawn trolleys to electric service, the service was first used in Forty Acres. In 1888, the WCRC introduced the first electric car brought into service, a 16-foot car known as Trolley Car No. 25. Once deemed successful, other electric cars were introduced to all of the city's trolley routes. These early electric passenger trolley cars maintained single trucks (four wheels) that ran on tracks and were powered by overhead electric lines. (Both courtesy of the Delaware Historical Society.)

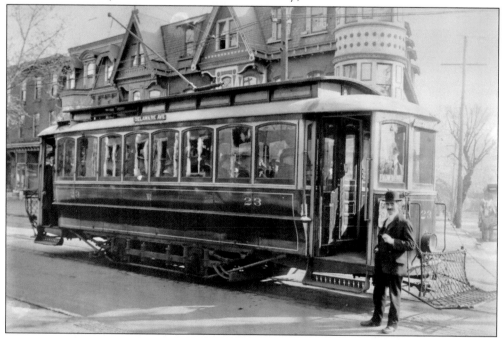

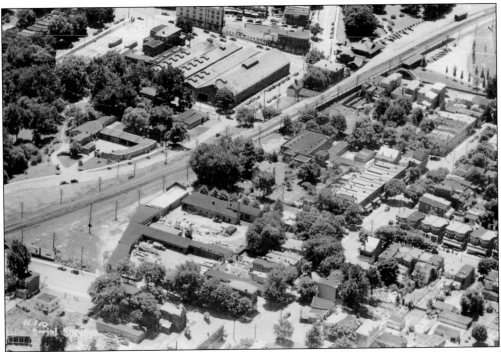

This 1930s aerial view details one half of the neighborhood. The Baltimore and Ohio Railroad tracks divide the neighborhood. Following the tracks from right to left, one may see how closely integrated industrial commercial sites blend with the neighborhood's residential housing. On the right side of the tracks is Frank W. Spark's construction company. The next large building on the same side of the tracks is the Nabisco Building. Just above that building on the opposite side of the railroad tracks, on the corner of Delaware Avenue and DuPont Street, is Kelly's Logan House. In the image detailing the WCRC site, the original brick office buildings are seen in the southeast corner of the lot at Delaware Avenue and Clayton Street, with at least two trolleys sitting in the main yard. This image illustrates exactly how large the WCRC site grew over the years. The carbarns soon consumed the entire city block bounded by Delaware and Gilpin Avenues and DuPont and Clayton Streets. They not only provided jobs for the men of Forty Acres as trolley drivers, mechanics, and office workers but also provided an income for surrounding businesses, such as the neighborhood diners and luncheonettes. (Courtesy of Hagley Museum and Library.)

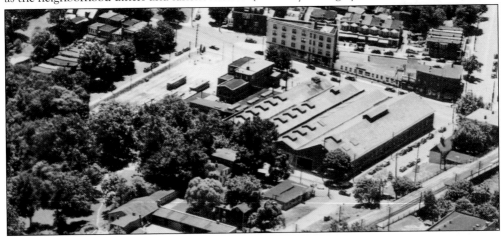

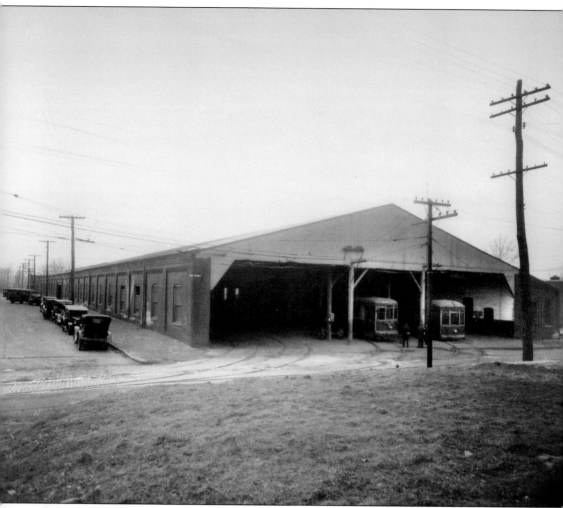

By the 1930s, the smaller carbarn shed (as seen on page 12) was replaced by a structure of grander proportions. This street-level view of one of the carbarns showing a number of trolleys housed within, as well as the two men standing in front of the building, allows for a better indication of the carbarn's true scale. (Courtesy of the Delaware Historical Society.)

Two

THE IRISH AND EARLY NEIGHBORHOOD RESIDENTS

After establishing the WCRC, Heald advertised extensively for people to leave the city for the suburbs, resulting in a housing boom for Forty Acres. The area was especially promising to men like John McKinney and other Irish immigrants, who purchased lots in this new section of the city that would be occupied by many future generations of their families. In 1866, John McKinney (seen here much later in his life) purchased land in Forty Acres where he built a home for himself and members of his extended family. (Courtesy of Cissy Kaiser Briggs.)

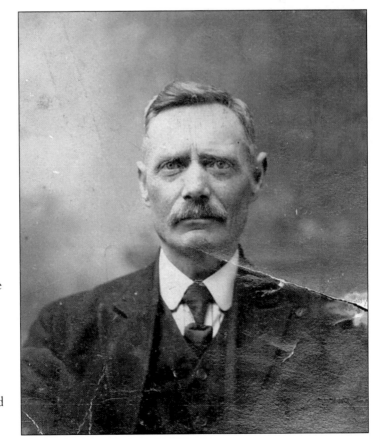

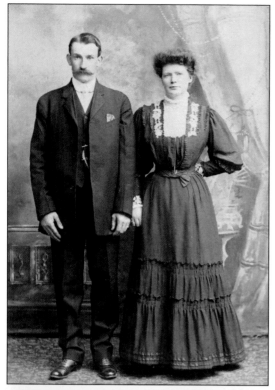

James and Mary Fitzharris (née McKinney) are pictured above left. Mary, the niece of John McKinney, immigrated to Delaware from the townland of Ballykeel, Newtownstewart, County Tyrone. Ballykeel is located between Omagh and Newtownstewart (eight miles from Omagh and three miles from Newtownstewart). After arriving in Delaware, Mary lived with her uncle before meeting and marrying James Fitzharris. The couple settled down in a two-story brick Italianate house on North Scott Street where they started a family. Five generations later, descendants of the Fitzharris family reside in the neighborhood today. The first home of James and Mary Fitzharris in Forty Acres was not to be permanent. Their eldest daughter, Nellie (at left below), had a habit of playing in the garden of a home just up the street from her own. When the property came up for sale, James declared that he would have to purchase the house if they were ever to keep Nellie at home. And so, the family moved half a city block. This photograph of Nellie Fitzharris was taken in 1916, about the time of the move. (Both courtesy of Cissy Kaiser Briggs.)

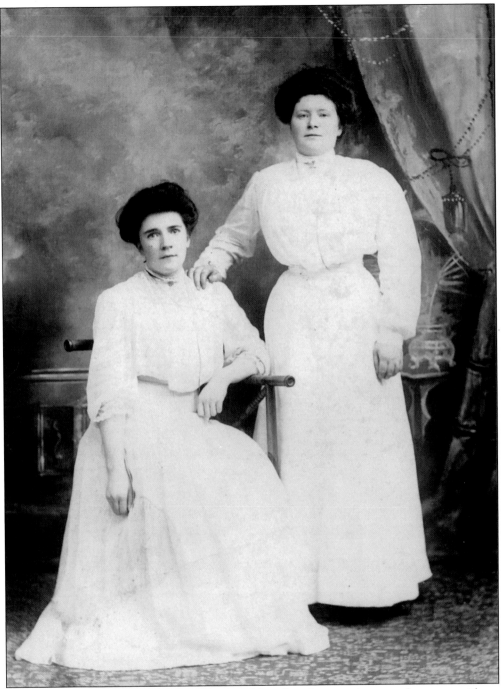

Many women of the Forty Acres neighborhood found work in service as cooks, nursemaids, or housekeepers in the homes of the wealthy along Delaware Avenue and in the stately houses of the nearby Highlands neighborhood. Pictured here are Catherine Malone (seated) and Anna Welch. These Irish sisters immigrated to Delaware from County Carlow, located in southeast Ireland just outside Dublin. The sisters lived in Forty Acres and worked as parlor maids for some of Wilmington's elite families. (Courtesy of Cissy Kaiser Briggs.)

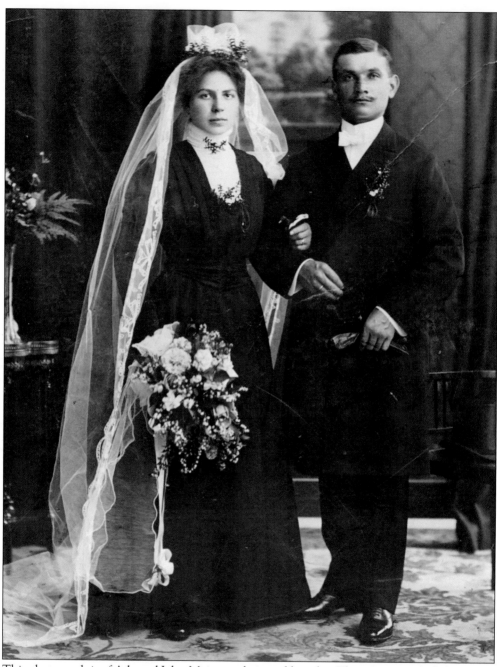

This photograph is of Ada and John Maier on their wedding day. They were popularly known in the neighborhood as "Momma" and "Poppy" Maier. They owned the icehouse once located at the corner of Shallcross Avenue and Lincoln Street. They lived on Shallcross Avenue in a house less than one city block away from their business. Many families of Forty Acres boast of having ties to the Emerald Isle and claim it to be a solely Irish neighborhood. While it is true that there exists a predominance of Irish families in Forty Acres, it is not entirely accurate to say it is only an Irish neighborhood. Like many neighborhoods, Forty Acres is home to families of many ethnicities; the Maiers immigrated to Forty Acres from Germany. (Courtesy of Cissy Kaiser Briggs.)

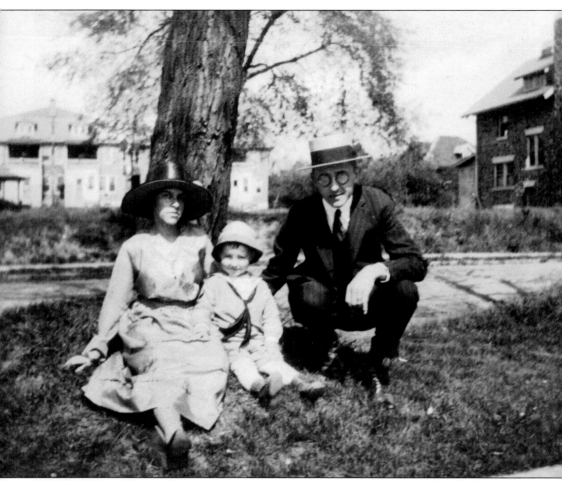

The Guthrie family moved to Forty Acres from nearby Pennsylvania. Here Jess, Curtis, and their son James, who lived on Shallcross Avenue, enjoy an informal family portrait in the park off Wawaset Street. This small park is located on the outskirts of the neighborhood and is still today a popular place for families to gather for picnics and other recreations. (Courtesy of Lauren Cardillo and Edie Guthrie.)

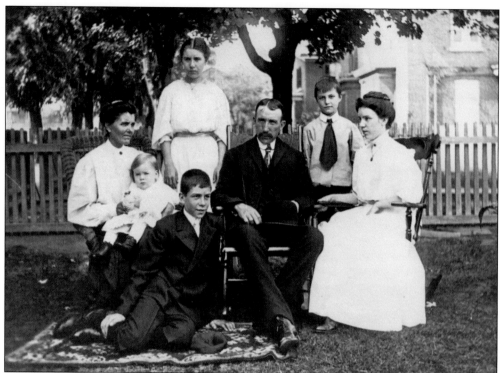

In 1890, James Black and his family posed outside of their home at 1817 Lovering Avenue for a portrait. Their house, although dramatically different in design from the dominating Italianate architecture in the neighborhood, was one of the first erected in Forty Acres. Many years later, at the same address, a husband and wife comfortably sit in rocking chairs under the shade of their small entry porch to have a photograph taken of their home. (Both courtesy of Robert Keller.)

Three

INDUSTRY

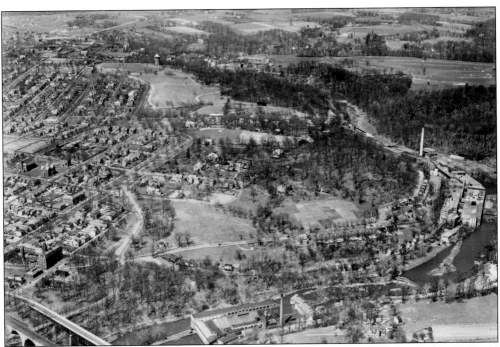

Employment and industry existed in what would become Forty Acres even before Joshua T. Heald set forth his plans of transforming this area into one of Wilmington's first streetcar suburbs. A series of paper and cotton mills were established along the Brandywine long before the neighborhood streets were laid. Some of these mills employed the men and women of Forty Acres well into the 20th century. Over time, the neighborhood developed as a mixed-use residential and commercial area. Industries other than the mills included a printing company, a brewery, and of course the trolley and bus barns. This c. 1930 aerial survey illustrates the proximity of a number of industries both within and outside of the Forty Acres community. The Hartmann and Fehrenbach Brewery is seen at the lower left, the Riddle Mill complex is visible at bottom center, and the Bancroft Mill is located at the center and far right of the photograph. (Courtesy Hagley Museum and Library.)

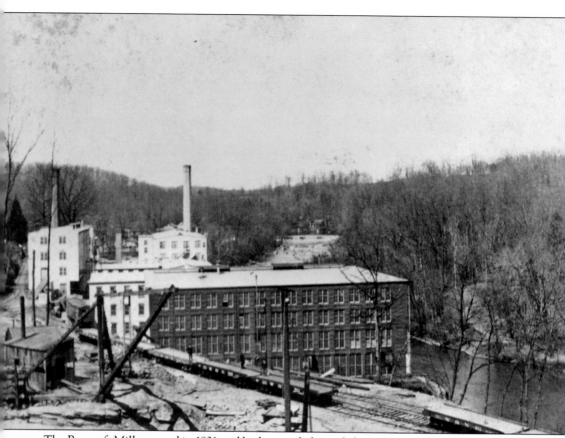

The Bancroft Mills opened in 1831 and had expanded greatly by 1895. By 1930, Bancroft Mills was the single largest cotton finishing works in the world. The mill continued in operation through the 20th century and eventually became known as the Wilmington Piece and Dye Company. The mill closed its doors forever in May 2003. Although a number of plans exist for the old mill site, its fate is unknown. (Courtesy Hagley Museum and Library.)

White- and blue-collar workers alike found employment in a wide variety of positions at the Bancroft Mills. These 19th-century images depict both a number of the mill's office workers and its machine shop employees. (Both courtesy Hagley Museum and Library.)

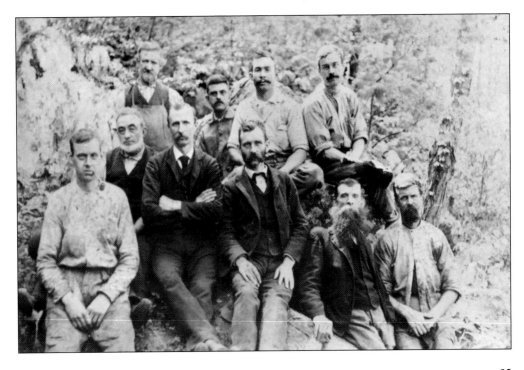

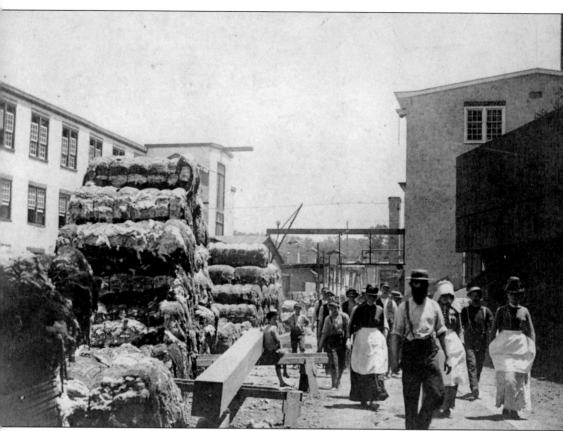

Work at the mill saw every stage of the milling process, from the delivery of raw materials to the resulting bolts of fabric in its finished product. In this photograph, mill workers—men, women, and children—pass heaps of cotton while walking through the Bancroft Mills complex. (Courtesy Hagley Museum and Library.)

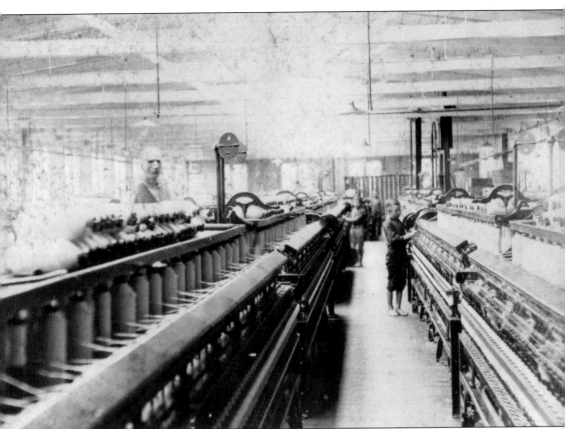

Before 1913, child labor laws did not exist in the state of Delaware to protect minors from psychologically or physically damaging jobs. These three barefoot children, known as "spinners," are seen inside Bancroft Mill working the mule spinning machines. These "mules" were multi-spool spinning wheels that dramatically reduced the amount of work needed to produce yarn, with a single worker able to work eight or more spools at once. (Courtesy Hagley Museum and Library.)

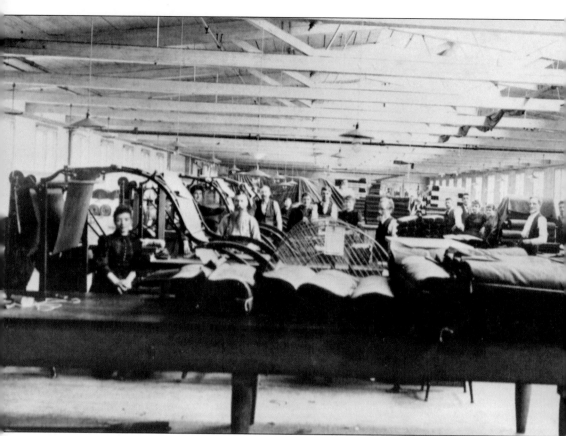

One of the last stops for the finished product in the processes of the Bancroft Mills is the finishing and folding room. This image shows a number of men and women employed in this, the last portion of the milling process. (Courtesy Hagley Museum and Library.)

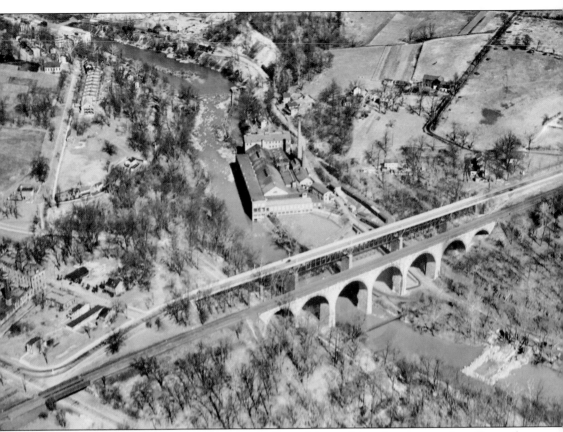

A 1930s aerial survey illustrates another mill (center) located just downstream from Bancroft. Known as the Riddle Mill, this complex began its life in 1787 as the Gilpin Paper Mill, established by Joshua and Thomas Gilpin. In 1816, Thomas Gilpin patented the first endless sheet machine in America, thus revolutionizing paper manufacturing by increasing the production of paper while reducing the cost of the process. By 1838, James Riddle purchased the Gilpin Mill and converted it to a cotton mill. Also seen just below the mill and in the following order is, from top to bottom: the Augustine Bridge, the Baltimore and Ohio Railroad bridge, and the "swinging" bridge. (Courtesy Hagley Museum and Library.)

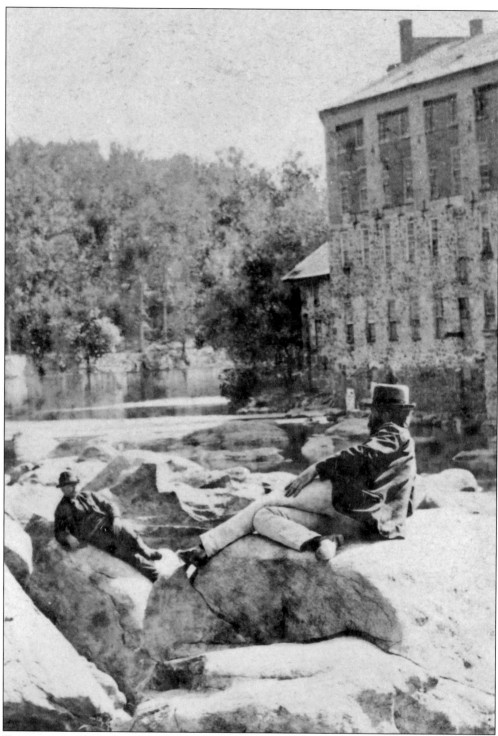

Two men, possibly workers from the nearby Tyre quarry, take a relaxing break to enjoy the warming comforts of the sun while reclining on rocks in the Brandywine Creek. To the west up the creek is Riddle Mill. (Courtesy Hagley Museum and Library.)

By 1885, the brewery expanded the buildings, and Hartmann and Fehrenbach held a high reputation for the quality and purity of its lager, porter, ale, and brown stout. In the fall of 1899, the brewery was awarded top honors from the National Export Exposition of Philadelphia. (Courtesy of the Delaware Historical Society.)

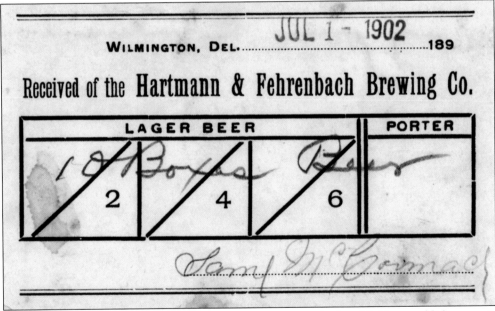

It was possible for individuals, as well as taverns, taprooms, and other drinking establishments, to make purchases from this local neighborhood brewery. Illustrating this example is a receipt dated July 1902, from the Hartmann and Fehrenbach Brewery. The order by Sam McCormac is for 10 boxes of beer. (Courtesy of Morris Library Special Collections, University of Delaware.)

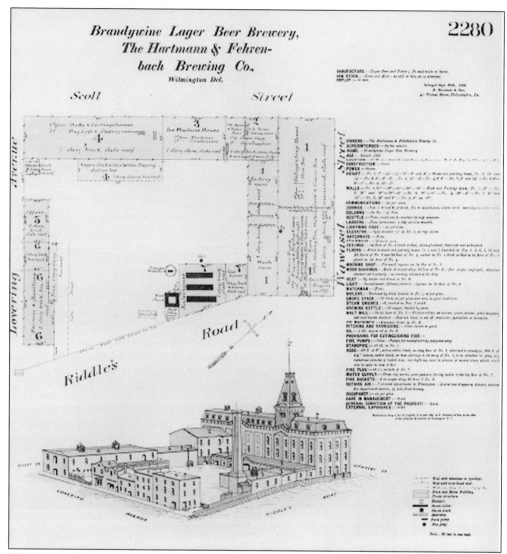

The original Hartmann and Fehrenbach Brewery, built around 1865 at North Scott Street and Lovering Avenue, was situated on an impressive three-acre complex. By 1868, the prolific brewery had the capacity to produce 35,000 barrels annually. (Courtesy of Hagley Museum and Library.)

Four

RECREATION

For most people, some of the grandest memories stem from family and childhood recreational experiences. The neighborhood of Forty Acres, while a small and compact urban area, is surrounded by a bounty of parks and hiking trails and is adjacent to the Brandywine Creek. There are any number of places for families and children to gather together. In this *c.* 1900 photograph, toddlers James Guthrie (left) and Robert Pierce pose for a picture in the neighborhood park just off Wawaset Street. (Courtesy of Lauren Cardillo and Edie Guthrie.)

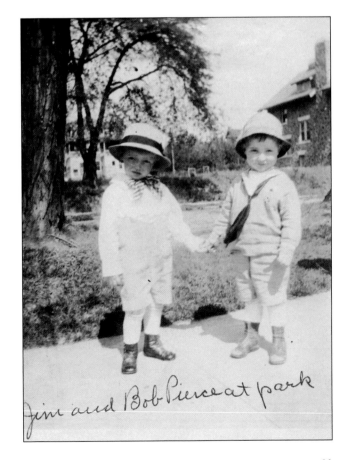

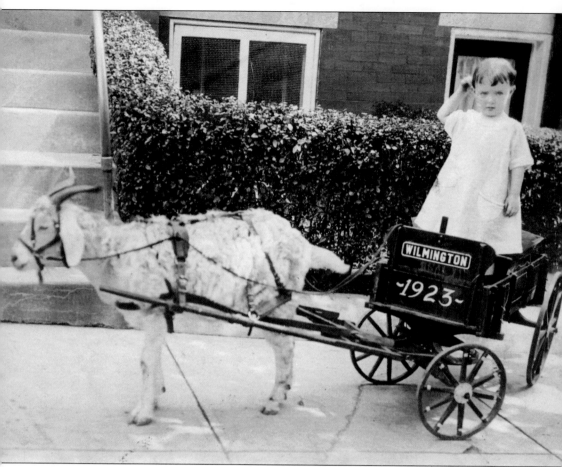

This young Forty Acres child enjoys a portrait taken in a cart pulled by a goat. Many traveling child portraitists were known to snap shots of neighborhood wee ones in carts like this. If the props were not a goat and cart, they might be a spotted pony with a western vest and a cowboy hat. (Courtesy of Paul M. Schofield Sr.)

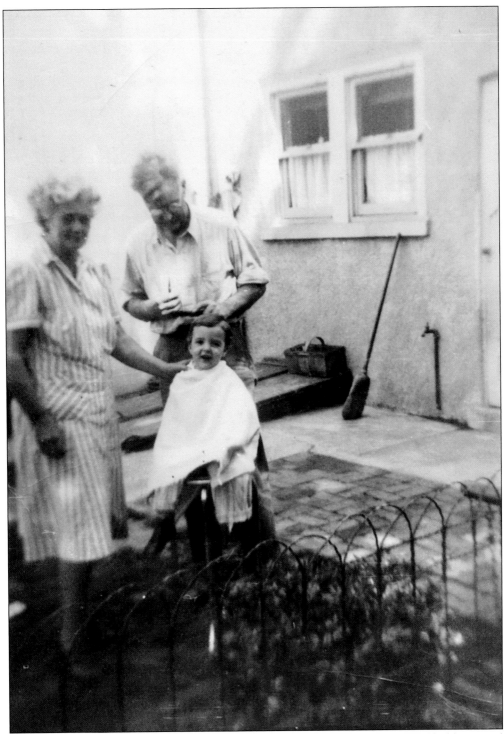

Even the mundane, day-to-day dealings of life, such as having one's hair cut, may hold a special significance. In this *c.* 1950 picture, young James Loving is on the receiving end of a haircut from his father, George, while his mother, Mildred, looks on. (Courtesy of private collection.)

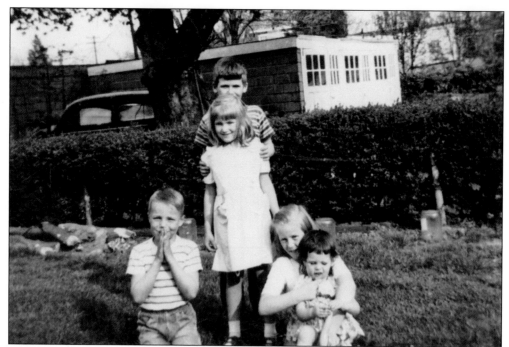

A romp in the backyard or even lunch outside might spark childhood imagination and excitement. Children of the Kaiser and Fitzharris families play in the backyard. Young James Kaiser (center), who was never one to enjoy having his picture taken, pulls his sister Elsie in front of him just as the photograph is snapped. From left to right below, in spring of 1947, neighborhood children Jimmy Kaiser, unidentified, Johnny Loving, Bobby Gotchalk, and George Loving enjoy a backyard picnic lunch. (Both courtesy of Cissy Kaiser Briggs.)

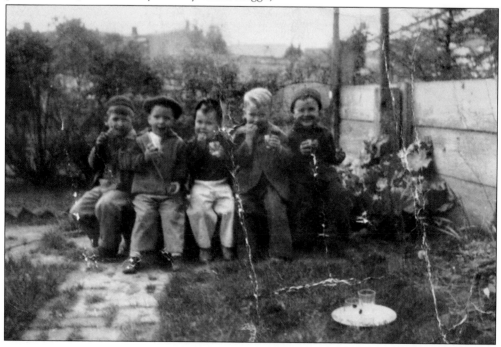

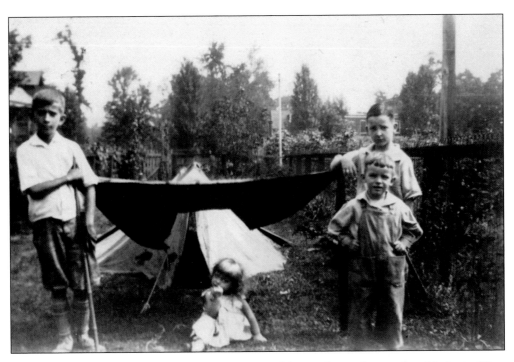

More recreational activities might include creating a club complete with secret handshake, building a tree fort, or putting up a tent in the backyard. In these c. 1910 photographs, James and Edward Guthrie, Junior Welch, and Ann Ballock stand in front of a newly erected tent (above). Stopping to pose for one more photograph sitting in front of the tent are James, Betty, and Edward Guthrie, Junior Welch, and Ann Ballock (below). (Both courtesy of Lauren Cardillo and Edie Guthrie.)

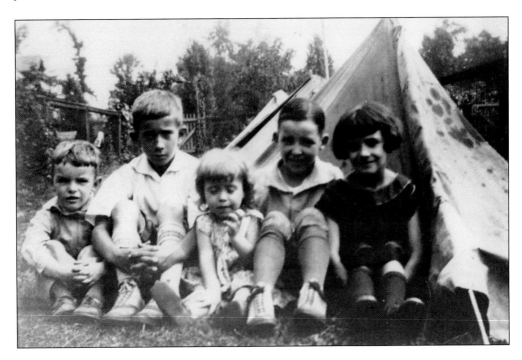

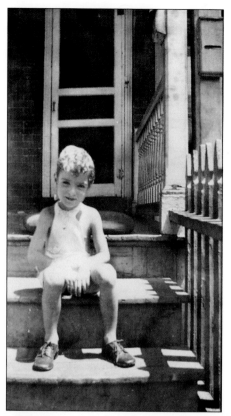

At times, simply having a seat on the front stoop to watch neighborhood life unfold is just as much fun as anything else. This is especially true in an urban environment, where any number of activities may occur even in the time span of one hour. Young Paul Michael Schofield sits on the stoop of his home on Delaware Avenue to watch the world go by while Edward (below, right) and James "Toothless" Guthrie do the same on Shallcross Avenue. (Left, courtesy of Paul M. Schofield Sr.; below, courtesy of Lauren Cardillo and Edie Guthrie.)

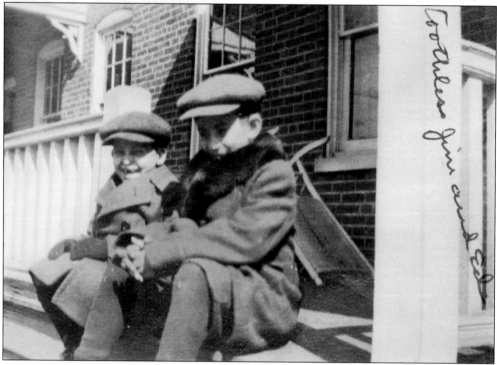

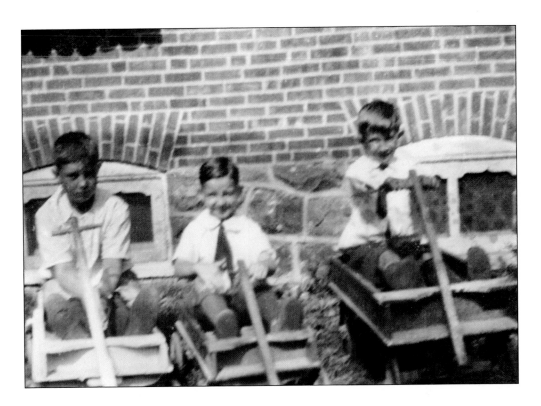

No matter what the year, wagons, carts, and other types of push-powered toys could hold the excitement and fascination of any child. In the first quarter of the 20th century, from left to right, James, Edward, and Marvin Guthrie enjoy playing with their wooden wagons. Below, children might also entertain themselves learning to master a musical instrument, just as these children of the neighborhood children's band do. (Both courtesy of Lauren Cardillo and Edie Guthrie.)

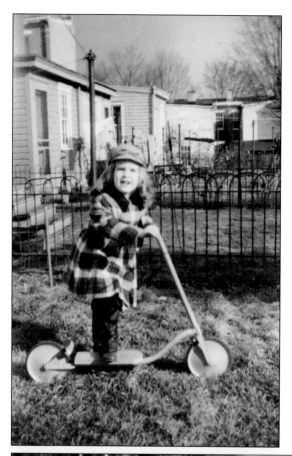

Scooters, wagons, and push mobiles of course are not toys intended only for boys but are known to fill hours of amusement for many young girls as well. This image of young Jacqueline Steptoe traveled to the South Pacific during World War II in order to bring comfort to her enlisted father. Her mother informed him of how Jacqueline "just flies all around on her scooter." Some years later, in September 1963, Julie Kaiser fills the last few days of summer with fun on her little red push mobile. (Left, courtesy of Jackie Walls; below, courtesy of Cissy Kaiser Briggs.)

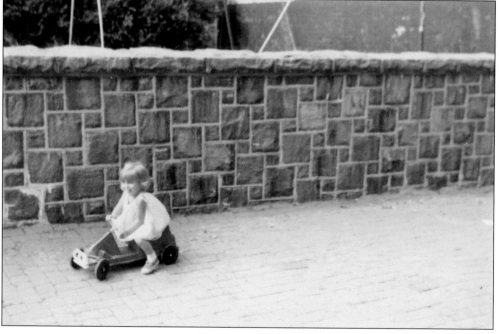

Family gatherings and other celebrations are always a part of recreational life in any neighborhood. In this image at right, Mary Conley watches her niece Maureen enjoy a soda at a summertime family reunion around 1951. Below, some years later in the early 1980s, at a children's birthday party, Margaret "Peggy" DiIenno talks with her daughter Nina. Her son John is holding a balloon while young Nellie Seal stands by. (Courtesy of Cissy Kaiser Briggs.)

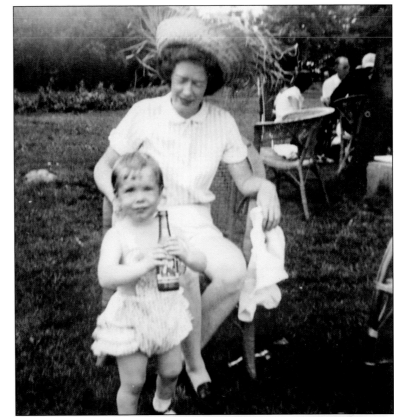

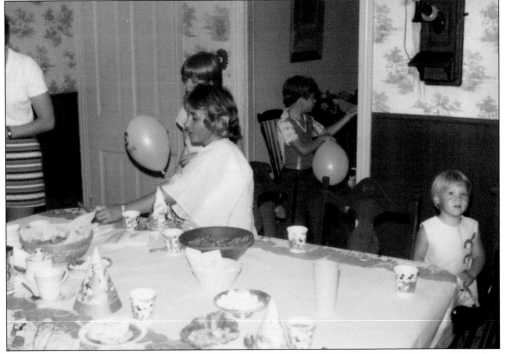

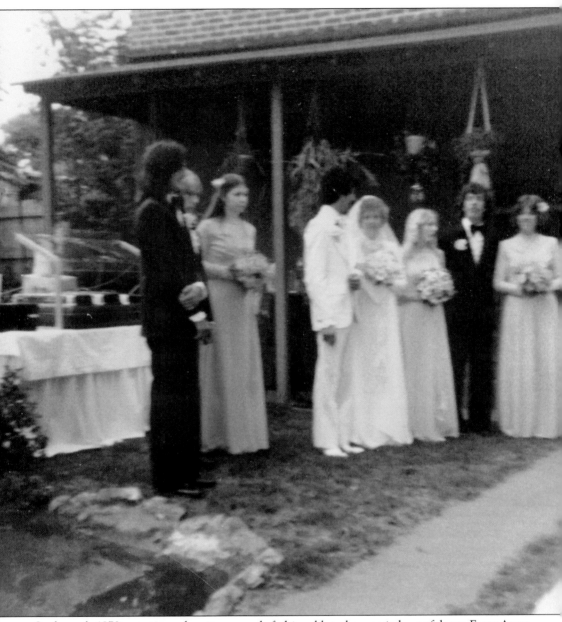

In the early 1970s, at a time when it was newly fashionable to be married out of doors, Forty Acres resident JoAnn McHugh held her wedding ceremony in the back garden of her family home on Shallcross Avenue. (Courtesy of Ann Faulkner.)

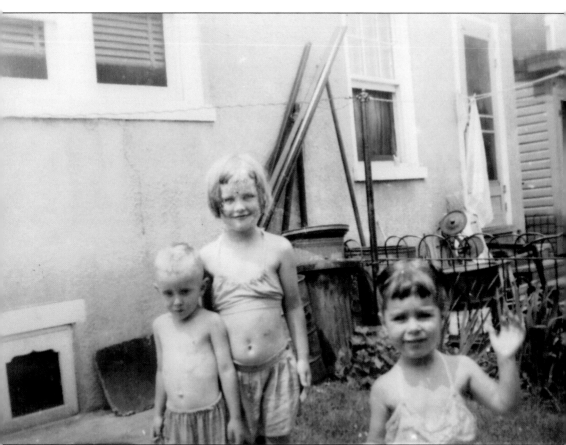

Forty Acres, like many neighborhoods on the Eastern Seaboard, is no stranger to hot summer days and nights. High temperatures combined with heavy humidity make for uncomfortable conditions. In July 1950, from left to right, Jay Reed, Mary Jean, and Cynthia Steptoe find ways of escaping the summer heat. (Courtesy of Jackie Walls.)

All children find ways of amusing themselves in any sort of weather. In this 1959 photograph, Francis Gallagher (above, left) and Fritz Horisk find ways of escaping the blistering July heat by splashing about and getting soaked with water in the lot at Williamson and Lincoln Streets. Likewise, in the winter of 1969, no extreme of snow and cold weather could keep these Forty Acres boys from the tackling pile in this Lincoln Street game of football. (Both courtesy of Cecilia Gallagher.)

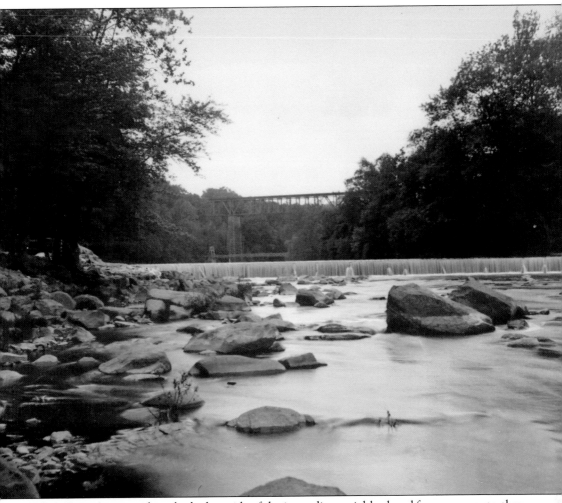

When Forty Acres residents looked outside of the immediate neighborhood for amusements, they often turned to the nearby parks of Rockford, Wawaset, and Brandywine and the Brandywine Creek for recreation. The Brandywine runs parallel to the northern border of Forty Acres and has always been a favorite spot for swimming, fishing, canoeing, or tubing. This view of the Brandywine looks west over the falls and towards the foot or Swinging Bridge (foreground) and the Baltimore and Ohio Bridge. (Courtesy Hagley Museum and Library.)

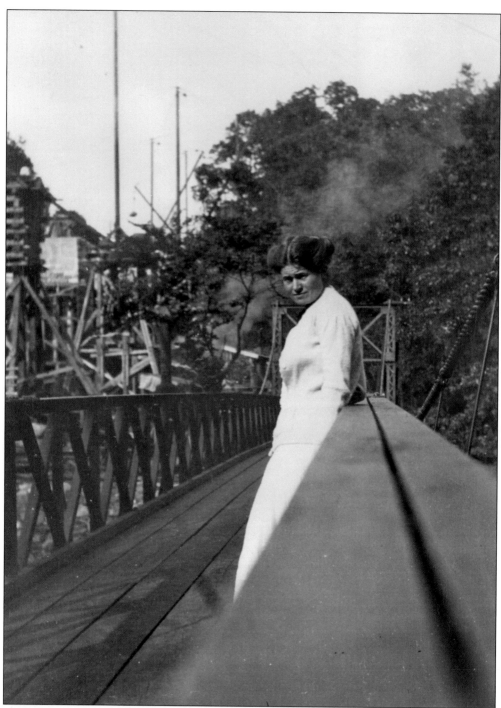

With the exception of the mills, now gone, this area of the Brandywine has changed little over the years. This *c.* 1910 picture shows Dorothy U. Lee standing on the Swinging Bridge over the Brandywine Creek. At that time, reconstruction of the Baltimore and Ohio (B&O) Bridge as a stone arched structure had already commenced. The wood scaffolding for construction of the granite bridge is seen on the left side of the picture. (Courtesy Hagley Museum and Library.)

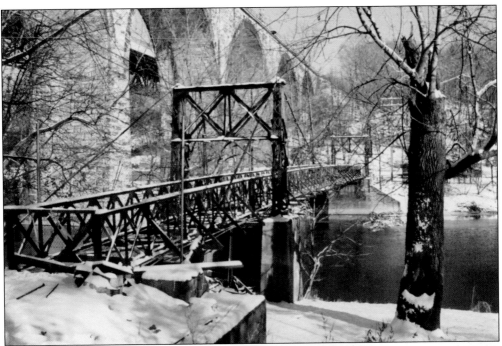

Almost 80 years later, a winter photograph of the Swinging Bridge at very nearly the same vantage point displays little to no change in the area. Also seen in this 1989 image are the completed granite B&O Bridge (now the CSX Railroad line) and the Augustine Bridge, visible through the stone arches of the old B&O Bridge. Facing the other direction, from left to right, Jacqueline, Cynthia, and Mary Jean Steptoe pose for a photograph at the t. (Above, courtesy of Cissy Kaiser Briggs; right, courtesy of Jackie Walls.)

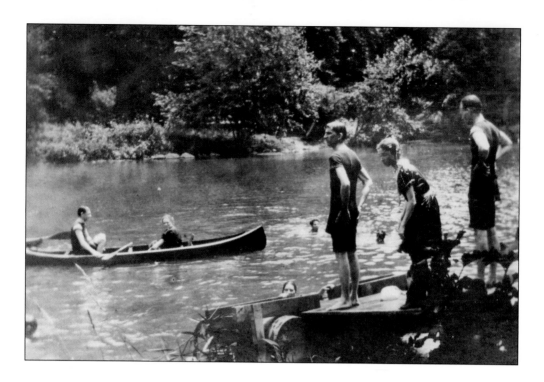

The Brandywine River or Creek (sometimes pronounced "crik" by locals) has always been a fun spot for swimming or canoeing. The early-1900s picture above shows a group of friends jumping from a small pier to cool off in a swim while two others look on from the canoe. In the summer of 1929 (below), John Fitzharris (second row, second from left) and a group of friends pose for a photograph alongside their canoe before a trip down the Brandywine. (Above, courtesy of Hagley Museum and Library; below, courtesy of private collection.)

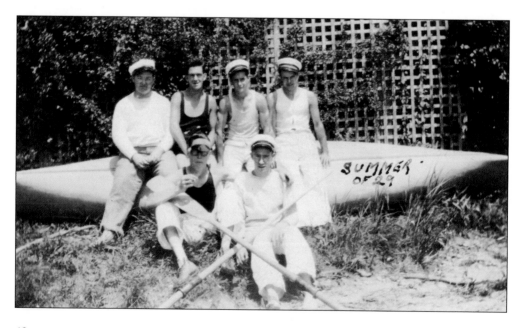

A short walk from the grid of asphalt streets in Forty Acres is the verdant oasis of Brandywine Park. This picturesque recreational area running along either side of the Brandywine River is a wonderful place to hike, bike, picnic, or simply sit and collect one's thoughts among a variety of native species of trees and plants while enjoying a symphony from a host of song birds. Brandywine Park is enjoyed by many throughout the four seasons. In a spring of the early 1940s (right), Marion Banks chose to have her picture taken in this lovely spot. In February 1951 (below), Sara Steptoe and daughters Jacqueline, Cynthia, and Mary Jean pose together at the Brandywine. This particular spot marks the location where the Brandywine Raceway begins. (Right, courtesy Elsie Kaiser Briggs; below, courtesy Jackie Walls.)

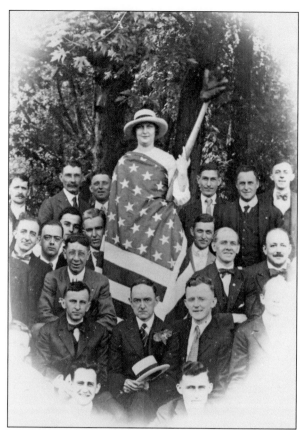

The Bancroft Mill held a number of employee functions, such as this Fourth of July employee picnic, and allowed for company-endorsed team sports like the Bancroft Bowling League. (Left, courtesy Hagley Museum and Library; below, courtesy Robert Keller.)

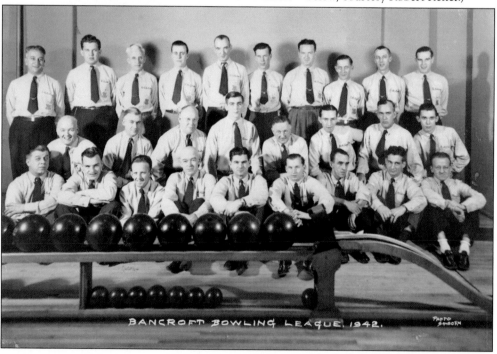

BANCROFT BOWLING LEAGUE. 1942.

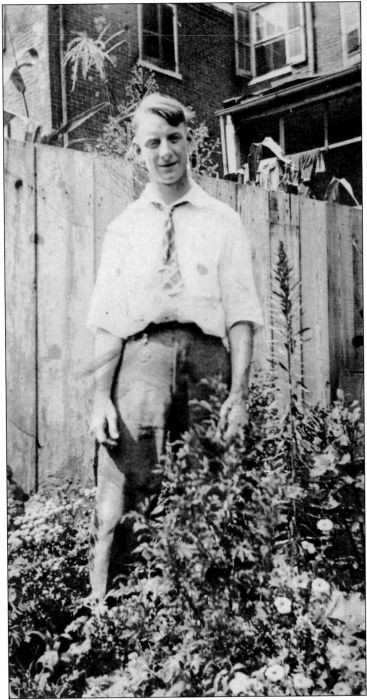

The backyards of most Forty Acres homes are situated on long and narrow plots of land. Even so, many neighborhood residents over several generations have enjoyed planning and organizing their bit of earth into lovely gardens as places to relax while getting in touch with the earth and themselves. Here Edward Schofield proudly stands among the plants in his back garden. (Courtesy of Paul M. Schofield Sr.)

Most Forty Acres homes are built quite close to the street and pedestrian right-of-way, leaving little to no front garden space. However, those who do have room to garden in front of their homes, like many along Riddle Avenue, have created beautifully designed floral landscapes. Those who are capable of creating backyard gardens are always proud of the results of their labors. Below Conrad Faulkner poses with his prize zucchini. Faulkner was known locally as the "Governor of Lincoln Street" and was an accomplished gardener. Conrad worked at the Jasper Crane estate in Edgewood and was responsible for the first rose garden at Brandywine Park's Josephine Gardens. (Left, courtesy of Robert Keller; below, courtesy of Ann Faulkner.)

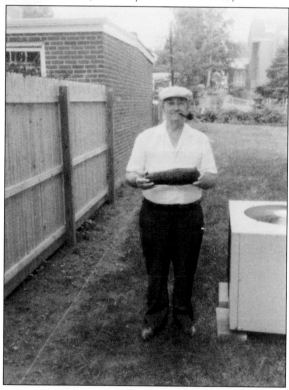

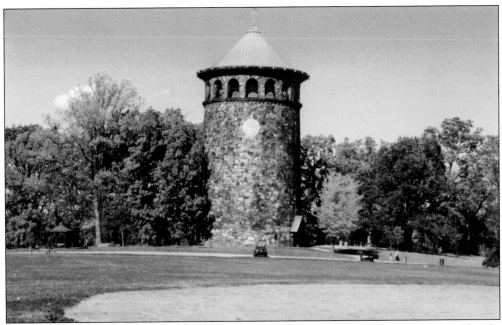

When not enjoying their own backyards, families within Forty Acres have a number of parks that surround the neighborhood in which to spend their hours of recreation. Rockford Park is one of the largest and most popular parks near the neighborhood. This vast, 100-plus-acre park is perhaps best known for its historic stone water tower (above). Visitors can climb the interior stairs of the 115-foot-tall tower to the observation deck, allowing for a 360-degree view of the park and surrounding city. As well as the tower, Rockford Park is known for its wooded trails and pastoral rolling hills. The park image below is taken from the perspective of its main hill. In winter months, this hill is a favorite for children of all ages for sledding and toboggan rides. (Courtesy of Helen Doherty.)

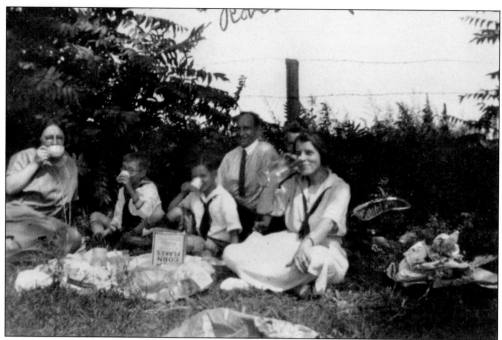

The upper portions of Rockford Park, in areas near the tower's base, are a series of lookout points with views of the Brandywine River. These vantage points are lovely spots to enjoy a picnic in the company of friends and family. These early-20th-century photographs illustrate members of the Guthrie family not only enjoying a packed lunch but one another's company. (Courtesy of Lauren Cardillo and Edie Guthrie.)

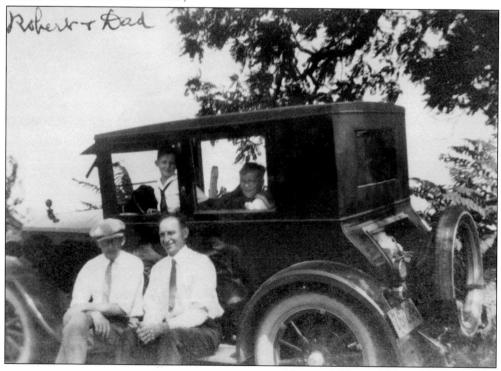

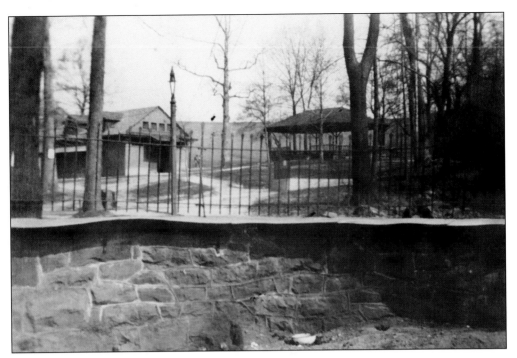

The Brandywine Zoo opened to the public in 1905. Some of the animals in the original collection included a bear and a sea turtle. Additionally, the zoo kept a building dedicated to exotic animals. The photograph above, taken about the time of the zoo's opening, is of the bear pit. Below, in 1950, Cynthia Steptoe has her picture taken with Big Pete the bear. (Above, courtesy of Lauren Cardillo and Edie Guthrie; below, courtesy Jackie Walls.)

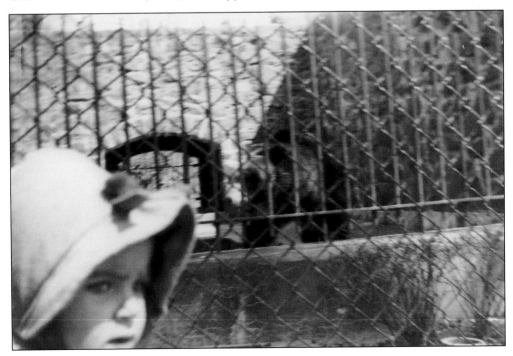

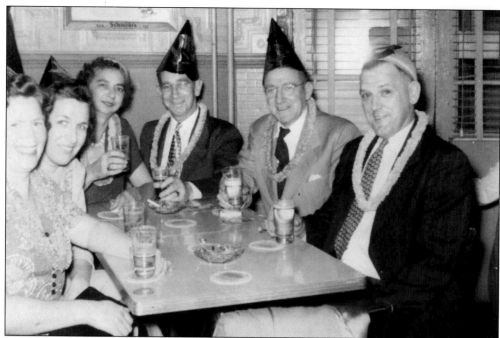

Recreation in Forty Acres was not only limited to outdoor fun but also included having a night out on the town. By the mid-20th century, the Hartmann and Fehrenbach Brewery was long-since closed. One of the remaining buildings of the complex became a restaurant and tavern called the Embassy. Sitting around a table above preparing to ring in the New Year in 1950 in the Embassy's main room are, from left to right, Nellie Kaiser, Ella Fitzharris, Emma and James Gilsin, John Fitzharris, and Charles Kaiser. Ever the elegant couple, Edward and Sabina Schofield enjoyed an evening of dining out among friends and receiving presents from Santa Claus. They are seen below at a 1962 Christmastime "pensioner's dinner" hosted by the Allied Kid Leather Company. (Above, courtesy of Cissy Kaiser Briggs; below, courtesy of Paul M. Schofield Sr.)

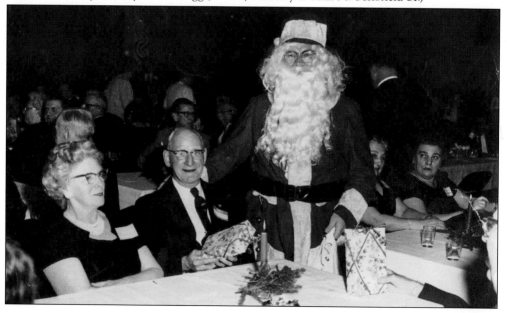

Five

RELIGIOUS LIFE AND EDUCATION

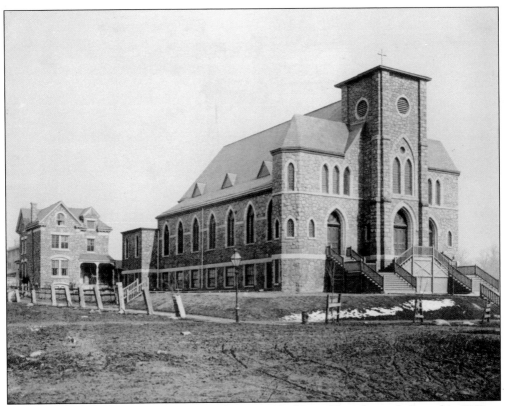

The first Catholic church in Forty Acres, known as St. James Chapel, was dedicated in 1869 on the north side of Lovering Avenue between DuPont and Scott Streets. Years later, when tracks of the B&O Railroad were laid close to the small chapel, it was decided that the parish would have to relocate. In December 1887, a new church was built and dedicated in honor of St. Ann at the corner of Gilpin Avenue and Union Street. This image of St. Ann's Church, with the parish rectory in the background, dates to the 1890s. (Courtesy of the Delaware Historical Society.)

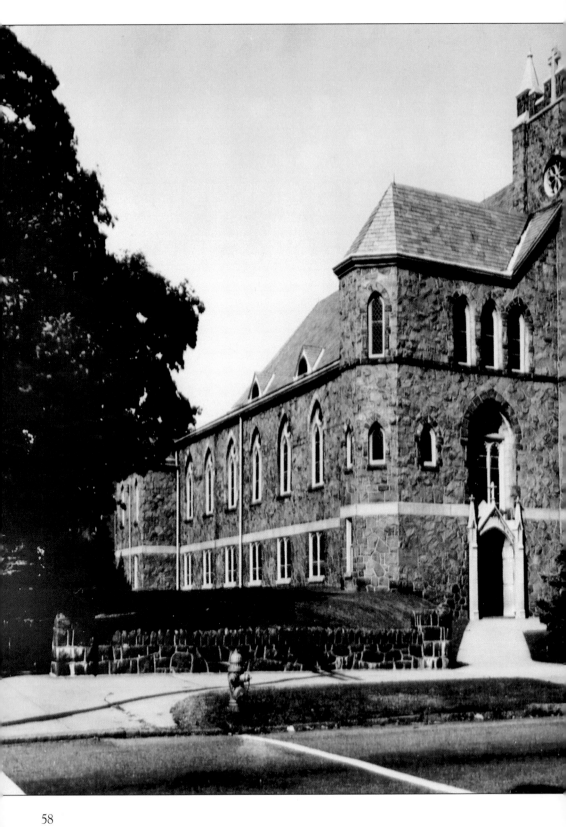

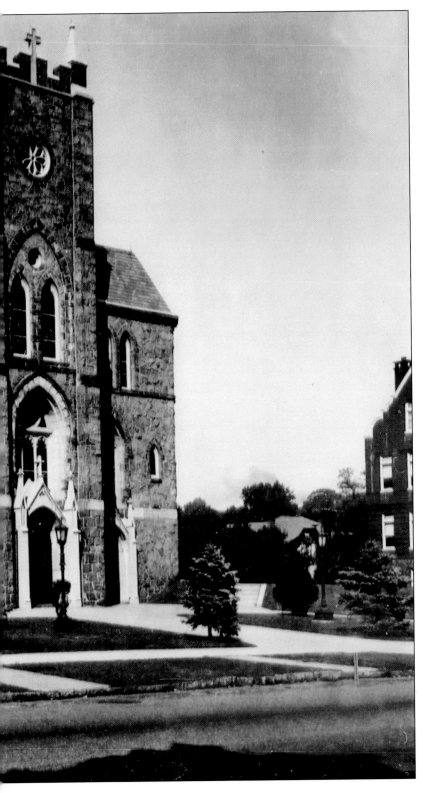

St. Ann's Church is seen as it looked in 1950. The church facade looks much the same as it did after its 1933 renovation. During that time, the front steps were removed, as was the upper church floor, so that the basement floor level became the floor of the church as well as the new entrance level. The upper-level doorways were converted to tracery windows, new entrances were constructed, and a stone wing was added to the rear of the church.

59

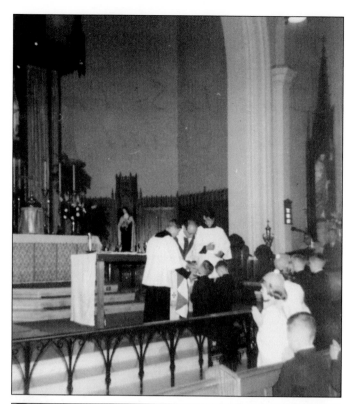

Usually at the age of seven, young Catholic-baptized boys and girls prepare for the sacrament of First Holy Communion. These young boys and girls are permitted to receive this sacrament only after careful instruction and after receiving the sacrament of First Penance or reconciliation. The First Holy Communion is a Roman Catholic ceremony and is a person's first reception of the sacrament of the Eucharist. These images show children receiving communion around 1965 and Jacqueline Steptoe on her first communion day. The 1950 photograph of Jacqueline was taken in the family's backyard. (Above, courtesy of Cecilia Gallagher; below, courtesy of Jackie Walls.)

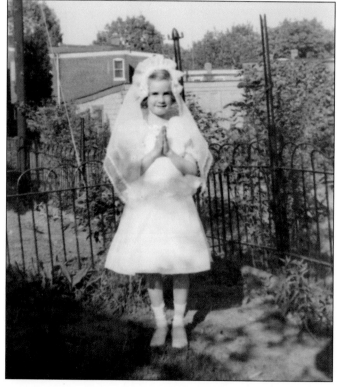

The First Holy Communion is a very important event in a young Catholic's life and a great family celebration. The day of First Holy Communion is a great day of celebration in the parish. The event is usually commemorated in a family photograph. In these pictures, members of the Schofield and Gallagher families are seen on their First Holy Communion Day. (Right, courtesy of Paul M. Schofield Sr.; below, courtesy of Cecilia Gallagher.)

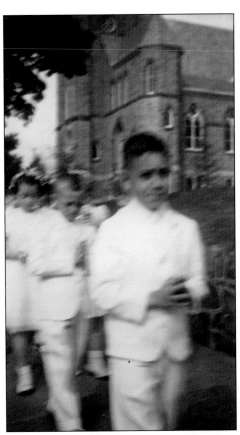

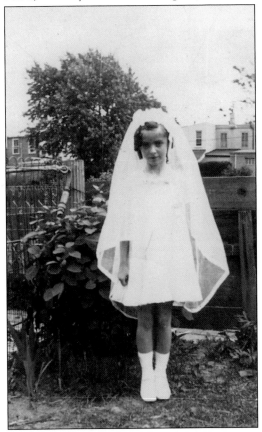

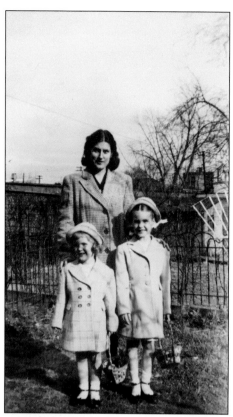

For a child who has already received his or her first communion, Easter is an extra special time. It is after First Holy Communion that he or she may fully celebrate and participate in the mass with the rest of the church parish. In these photographs from 1948 and 1951, Sara Steptoe (at left) poses with her daughters Mary Jean and Jacqueline. Below, from left to right, Jacqueline, Cynthia, and Mary Jean are pictured with their Easter baskets. (Courtesy of Jackie Walls.)

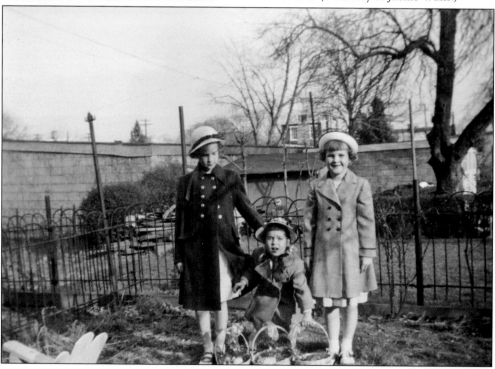

A great many priests did their utmost while in service at St. Ann's Church. Two priests who left a lasting legacy at St. Ann's were Msgr. John A. Corrigan and Monsignor Taggert. While pastor of Saint Ann's Church, Father Corrigan was responsible for many impressive changes to the church and school property. Through Father Corrigan's work with numerous volunteers, a new social hall and gym were dedicated in 1969. Msgr. Paul Joseph Taggert was known by all as an exemplary priest who fought for social justice and interfaith relationships. He worked to form the Delaware chapter of the National Council of Christians and Jews. In 1976, Monsignor Taggert met with members of the von Trapp family, of *Sound of Music* fame, who were with him on the day he celebrated his very first Mass at Saint Ann's in 1951. (Courtesy of the Diocesan Archives.)

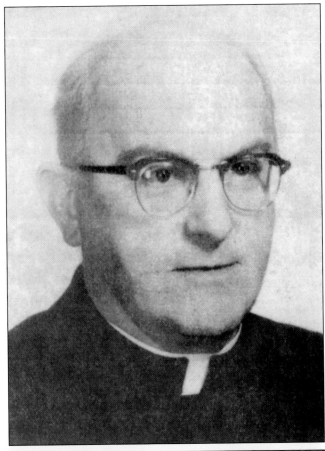

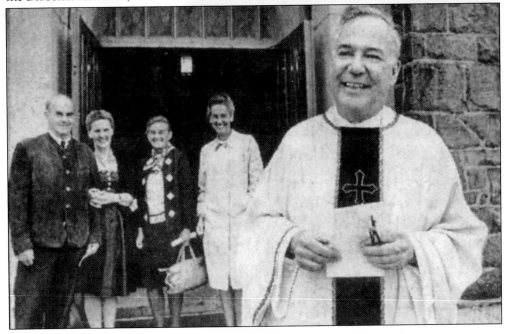

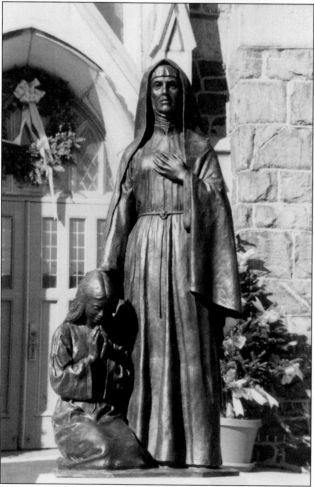

The Reverend Patrick Brady was pastor of Saint Ann's in its centennial year and led the celebrations that commenced in July 1987. It was through the work of Father Brady that Wilmington sculptor Charles Parks was commissioned to create a bronze statue of St. Ann with her daughter, the Virgin Mary. Since the installation of the statue, parishioners and neighborhood residents alike have taken a type of personal ownership of the statue. On any given day, one will notice flowers placed within the blessed mother's hands. (Above, courtesy of the Diocesan Archives; left, courtesy of Helen Doherty.)

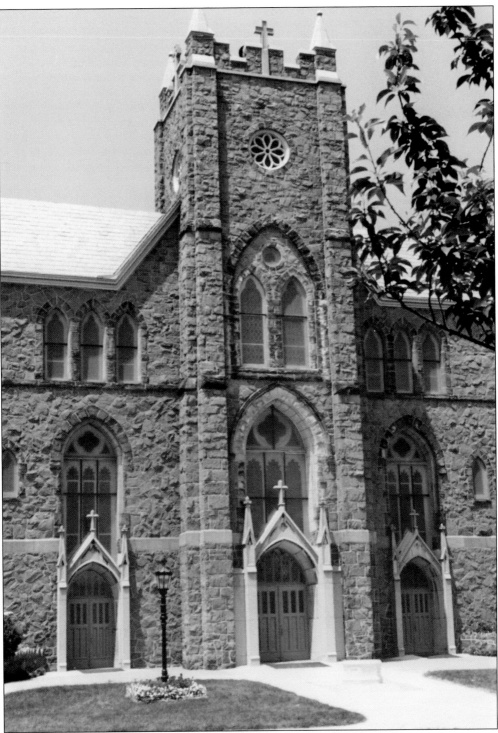

St. Ann's Church, pictured around 1987 with the newly installed concrete pillar outside its center doors, awaits the new statue of St. Ann and the Blessed Mother by Wilmington sculptor Charles Parks. (Courtesy of the Diocesan Archives.)

Every May, St. Ann's Church honors the Blessed Virgin Mary with month long tributes that include recitation of the rosary. This tribute once included what was called the May Procession. Pictured here from back to front are Father Eckrictt, Monsignor McElwaine, two unidentified girls, Elsie Marie "Cissy" Kaiser, and Barbara Ruff. A very nervous and solemn Cissy was selected as that year's (1960) May Queen to lead the parishioners of St. Ann's Church in reciting the rosary while parading a route around the church property. Four years later (below), a very happy Cecilia Gallagher leads the 1964 May Procession from St. Ann's Church. While St. Ann's Church continues the tradition of the May Procession, a May Queen is no longer selected to lead the march, as it was deemed too much of an exclusionary practice. (Above, courtesy of Elsie Kaiser Briggs; below, courtesy of Cecilia Gallagher.)

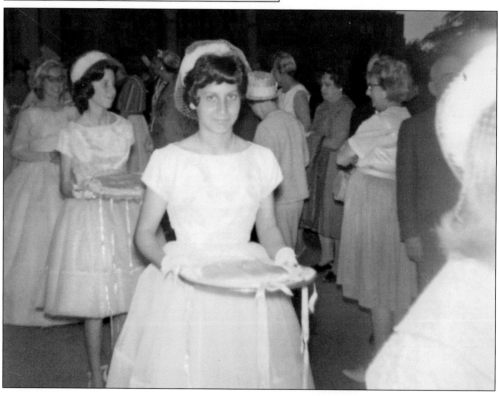

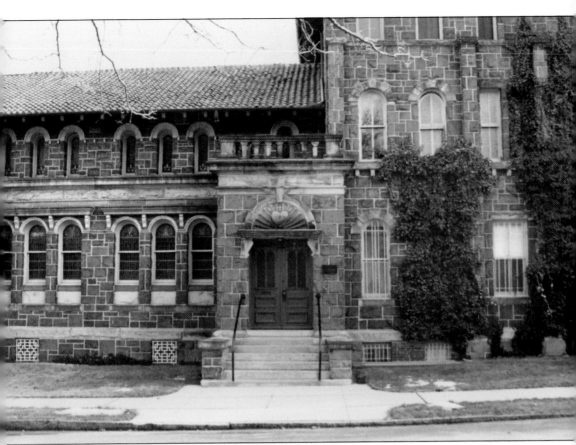

The Monastery of the Visitation, pictured around 1990, was located at 2002 Bancroft Parkway. The monastery, constructed in 1893, was home to the Sisters of the Visitation of Holy Mary, an order founded by St. Jane de Chantal and St. Francis de Sales in Annecy, France, in the year 1610. The concept of the founders was "to give God daughters of prayer, souls so interior that they may be found worthy to serve His infinite Majesty and to adore Him in spirit and truth." While the monastery was located just outside of Forty Acres, many young girls from the neighborhood had entered into this monastery, and it would be remiss not to include it. (Courtesy of the author.)

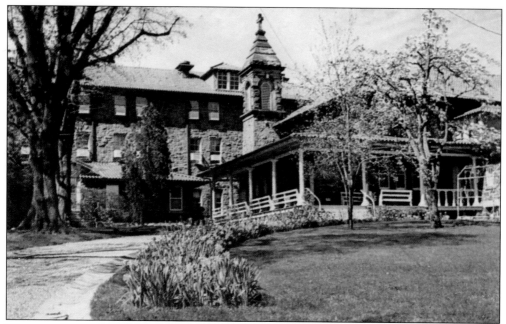

The monastery and its extensive gardens existed on one full city block. The Sisters of the Visitation lived the cloistered, contemplative life, meaning that once they entered the monastery and took solemn vows, they did not leave. In doing so, they abandoned a worldly life so that they could completely dedicate themselves to prayer. They served God and their community through prayer. The monastery was completely surrounded by farmland at the time of its construction. One hundred years later, the monastery found itself in the middle of a bustling neighborhood whose sounds and interruptions of the outside world interfered with their life of contemplative prayer. (Both courtesy of the author.)

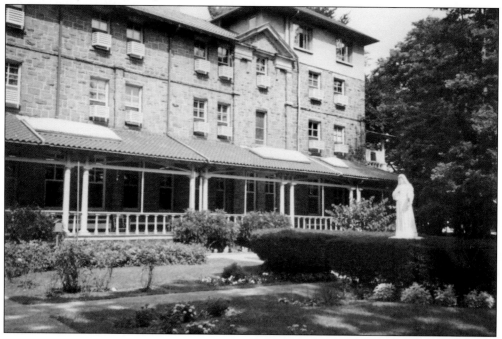

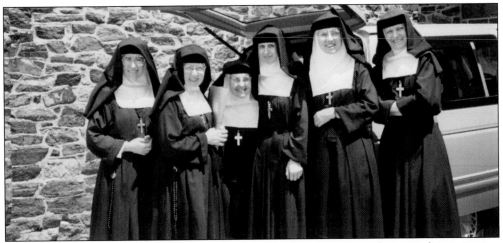

Interruptions from the outside world and concerns over extensive and seemingly continuous repairs to their monastery building ultimately caused the sisters to decide to relocate. After careful consideration and prayer, the community chose a move to a 117-acre property in Tyringham, Massachusetts. This is the last photograph of some of the Visitandines before they left Wilmington for their temporary home in Pittsfield, Massachusetts, where they resided in a convent while waiting for construction on their new monastery to be completed in Tyringham, Massachusetts. From left to right are Sr. Ann Therese Zorino, Sr. Alice Marie Landers, Sr. Marie Joan Kelly, Mother Margaret Mary Rumpf, Sr. Mary Charles Dougherty, and Sr. Judith Clare Phillips. In order to defray some of the costs of moving, the Sisters of the Visitation held an auction of many of their belongings. Items included not only furniture and statuary but also stained-glass windows from the Visitation chapel and musical instruments. Many people took part in the auction. Francis Doherty, a longtime Forty Acres resident, was on hand to do his own part in assisting the sisters. (Above, courtesy of the author; below, courtesy of the Doherty family.)

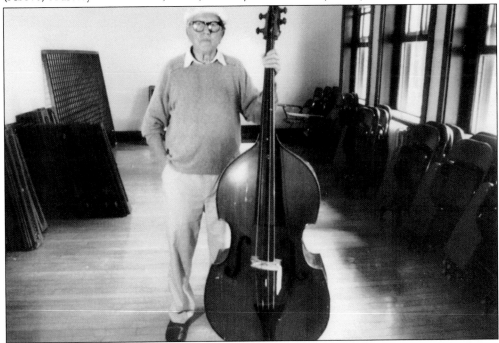

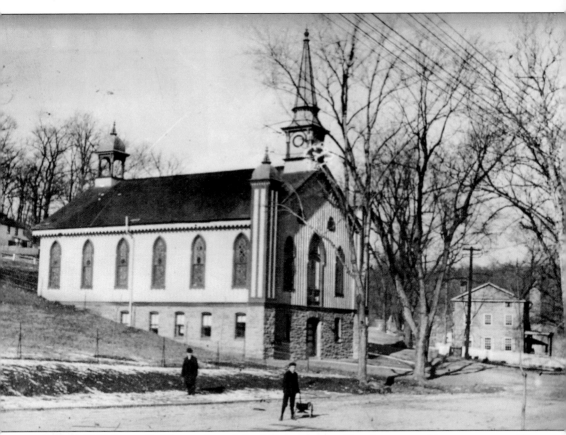

Around 1838, James Riddle purchased the Gilpin paper mill and converted it to a cotton mill. Riddle took on a paternalistic view of his employees and sought to care for many of their personal concerns. In addressing their spiritual needs, Riddle saw to the construction of chapels for his Catholic and Protestant workers. One of these chapels, established off present-day Riddle Avenue, was known as the Riddle Chapel and was organized for the mill's Protestant employees. By the mid-20th century, the chapel was converted to a community center. One resident recalls neighbors gathering together in the building to witness the debut of television. (Courtesy of Robert Keller.)

The Knights of Columbus organization, originally founded in Connecticut, is a lay Catholic fraternal organizational dedicated to the principles of charity and unity and serves as an advocate and defender of civil and religious rights for all. At the first part of the 20th century, Fr. Joe Burke of St. Ann's founded the Knights of Columbus council in honor of Bishop Francis J. Curtis, second bishop of Wilmington from 1886 to 1896. In addition to the council's works of charity for the community, they were also known for social contributions. In 1950, the council put on a passion play titled *Innocent Blood*, where Leo F. Higgins portrayed the role of Pontius Pilate.

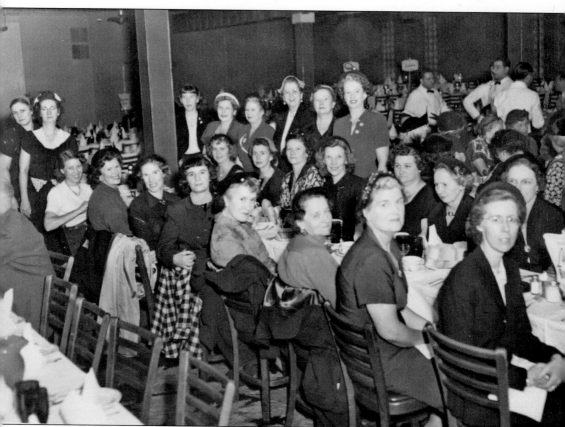

While the Knights of Columbus are a fraternal organization, wives of its members keep an auxiliary group. Pictured here is the Bishop Curtis Council Ladies Auxiliary at a Knights of Columbus convention held at Palumbo's restaurant in Philadelphia. The ladies are, as seated from left to right, Mrs. Jack Bullock (Ruth), Mrs. Charles Kaiser (Nellie), Mrs. Francis Grimes (Elanore), three unidentified, Mrs. Dennis Kelleher, and Mrs. Kane. All others are unidentified. (Courtesy of private collection.)

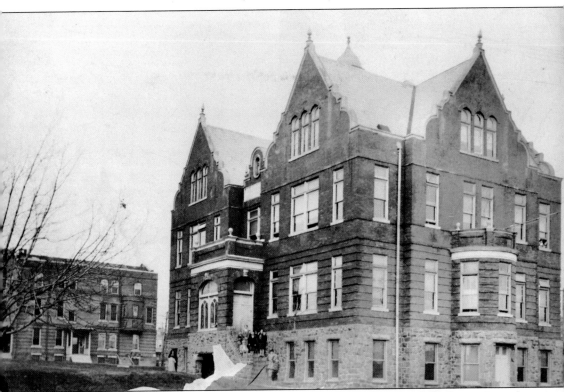

This 1929 postcard depicts the St. Ann's School, located at Union Street and Shallcross Avenue. The four-story brick building was constructed in 1898. At one time, all of the school's educators belonged to the Sisters of St. Francis. The nuns lived on the fourth floor or attic level of the school until 1910. It was then that the convent, which is visible in the background, was completed to house the sisters. (Courtesy of Cissy Kaiser Briggs.)

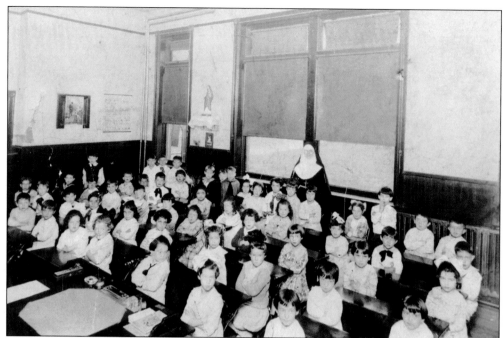

This Roman Catholic parochial grade school has educated children in grades first through eighth, one class per grade, since 1898. In the first years of the school, the sisters taught as many as 50 children per grade. These c. 1900 photographs of classes belonging to both lower and middle grades illustrate not only class size but also classroom environment. Ample amounts of natural light, displays of the Angelus and statues of the Blessed Mother, geography maps, and patriotic flags, along with lessons on the blackboard, attest to the type and quality of education received at St. Ann's School. (Both courtesy of private collection.)

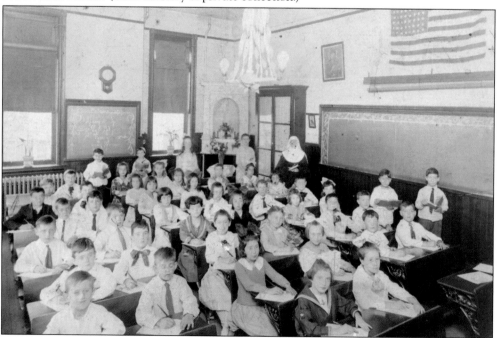

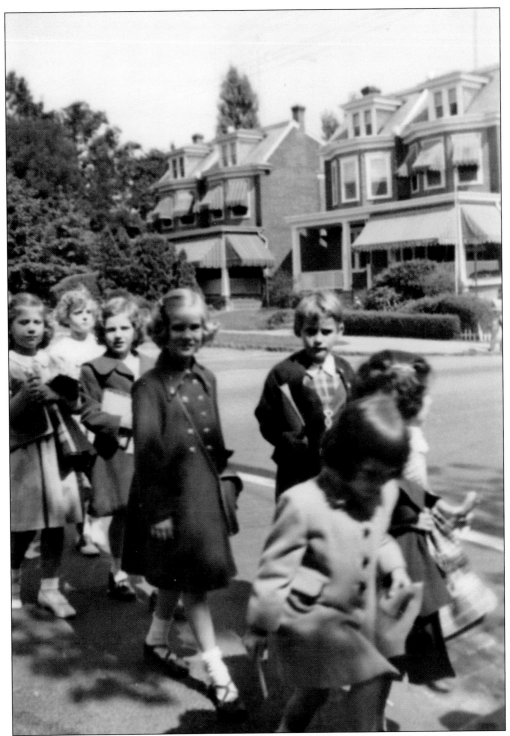

As the majority of the school's students lived in and around the Forty Acres neighborhood, it was easy to walk to school from home. In this picture, third-grade student Jacqueline Steptoe (center) walks with her class alongside the school building at Shallcross Avenue. (Courtesy of Jackie Walls.)

With excitement and perhaps a little anxiety, the first day of school brings a world of excitement for any child. In these pictures, sisters Mary Jean (left, center) and Jacqueline (below, first row, left) Steptoe have just completed their first day at school. They are seen leaving the school with other members of their class. At this time, the main entrance to the school faced Union Street. (Courtesy of Jackie Walls.)

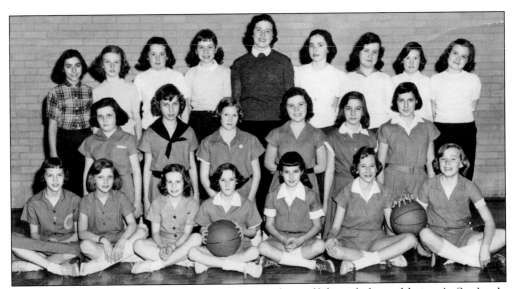

Many Catholic schools integrate religion into every facet of life, including athletics. At St. Ann's, programs focus not only on the human side of a student's athletic development but also on the spiritual, apostolic, and intellectual. This is achieved by encouraging fair play, discipline, self-confidence, and prayer. Success is not measured solely on wins and losses on the field or court but also in how well students are prepared for life. In the above 1958 photograph, the sixth- and seventh-grade St. Ann's girls basketball team is, from left to right, (first row) Beth Winnington, Janice Dick, Peggy Evans, Bridget Cummings, Barbara Ann Ruff, Lois D'Alonzo, and Sandra McFarland; (second row) ? McBride, Sharon Rubincam, Elsie Kaiser, Karen Darby, Margaret Johnson, and Katherine Gallagher; (third row) Mary Ann Vella, Mary Ann Farren, Winnie Duffy, Mary Galloway, coach Ann Forrest, Mary Theresa Dougherty, Lorraine Wix, Martha Jackson, and Catherine Wickersham. The 1956 football team is, from left to right, (first row) Mark Taylor, Jackie Taggart, Louie Bartoshesky, Francis (Zeke) Schofield, Jackie Williams, Harold ?, Michael Noonan (kneeling in front), Melville Hunter, Hank (Francis) Farren, James Noonan (kneeling in front), and Thomas Hazzard; (second row) Sean Mulhearn, Richard Hagan, Bobby Scully, John Taylor, Mike Rubincam (to rear), Michael Gifford, Joe Horgan, Hugh McBride, and Jackie Hahn; (third row) Jim Quinn, Marvin Schofield, Eddie Dickerson, Louis DiMascio, Johnny Joyce, and Tommy d'Alonzo. (Above, courtesy of Cissy Kaiser Briggs; below, courtesy of Diocesan Archives.)

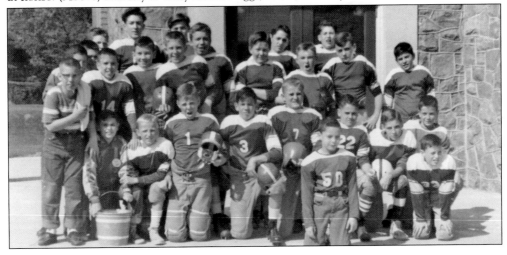

Field day at Rockford Park is pictured in June 1958. At left, Sister Aquanata watches over the St. Ann's grade school games. Perhaps tired of watching, Sister Aquanata finally joins in on the fun below. In the background, other classes of children gather together near the Rockford Park water tower. (Courtesy of Elsie Kaiser Briggs.)

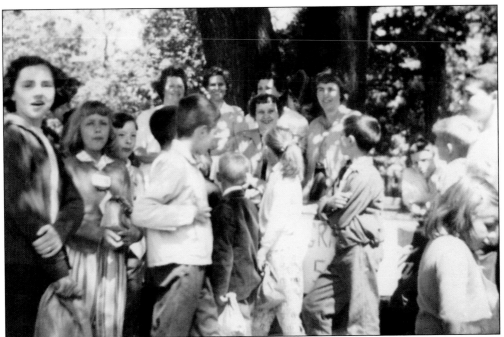

On field day, students and teachers of St. Ann's walked to Rockford Park to participate in a day of year-end fun filled with competitive athletic events and games. Each class gathers under a tree as a sort of "homeroom" location. Mary Theresa Dougherty (now Sr. Mary Charles of the Sisters of the Visitation Monastery at Tyringham, Massachusetts) joins with other members of her class under their designated tree before joining in on the Rockford Park field day events for St. Ann's School. Below, as part of the same 1958 field day exercises, a group of St. Ann's School children enjoys a game of baseball. (Courtesy of Elsie Kaiser Briggs.)

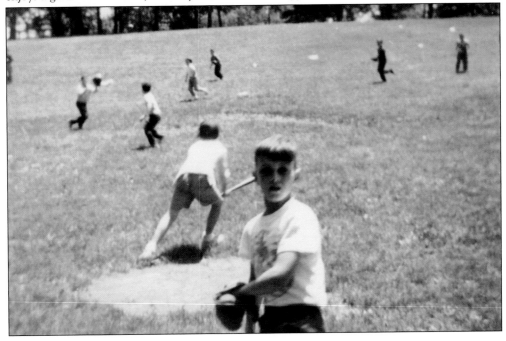

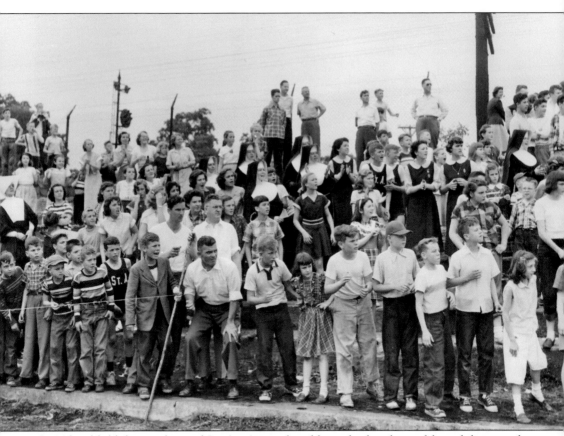

Outside of field day, students of St. Ann's are also able to display their athlete abilities at the diocesan games known as the Catholic Youth Organization or CYO. An excited crowd watches from the stands for runners to cross the finish line at this 1953 CYO track meet at Baynard Stadium in Brandywine Park. (Courtesy of the Diocesan Archives.)

Graduation from St. Ann's Roman Catholic parochial school commences with a baccalaureate mass and conferment of diplomas in the church. Pictured above around 1960 in procession from mass are, from left to right, Sharon Rubincam, Sandra McFarland, and Mary Theresa Dougherty. At right, about three years later, Mary Kaiser (in the foreground) walks with friends after leaving her baccalaureate mass at St. Ann's Church celebrating graduation from St. Ann's Grade School. (Above, courtesy of Cecilia Gallagher; right, courtesy of Elsie Kaiser Briggs.)

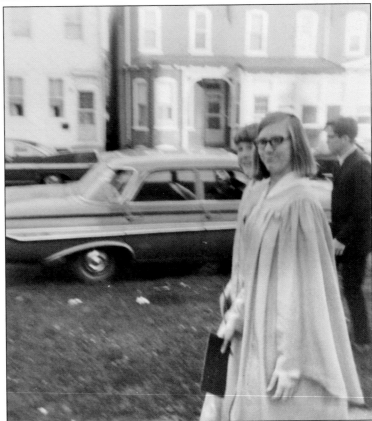

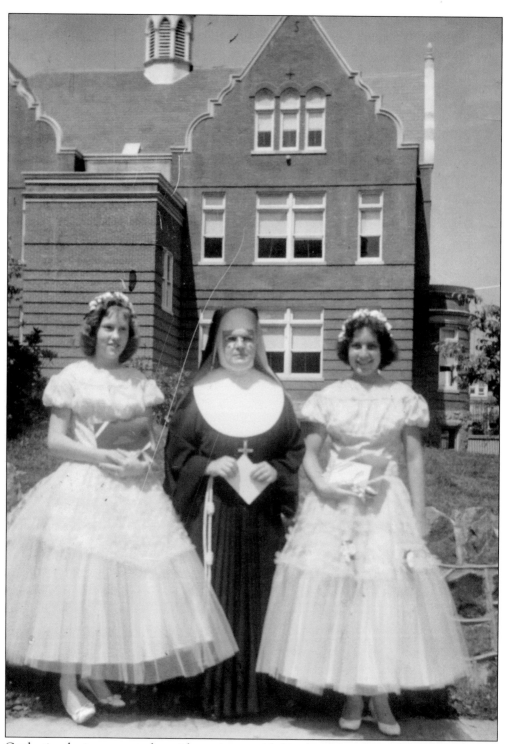

Graduation day is never complete without pictures with friends and favorite teachers. On graduation day in 1959, from left to right, Martha Jackson stands with principal and eighth-grade instructor Sister Agnes Assisi and Katherine Gallagher. (Courtesy of Cecilia Gallagher.)

Six

PEOPLE AND PLACES IN AND AROUND THE NEIGHBORHOOD

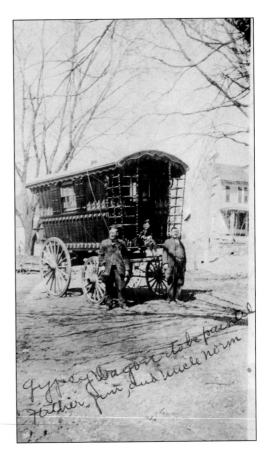

Life in Forty Acres always was and continues to be filled with colorful everyday and not-so-everyday events. One year a Gypsy caravan made its way into the neighborhood. In this c. 1900 photograph, from left to right, Curtis, James, and Norman Guthrie have been hired to paint one of the Gypsy wagons. Outside of these extraordinary happenings, the neighborhood contains a variety of stores and places, each with a unique story to tell and people who are proud to call one another "neighbor" and are concerned for each other. (Courtesy of Lauren Cardillo and Edie Guthrie.)

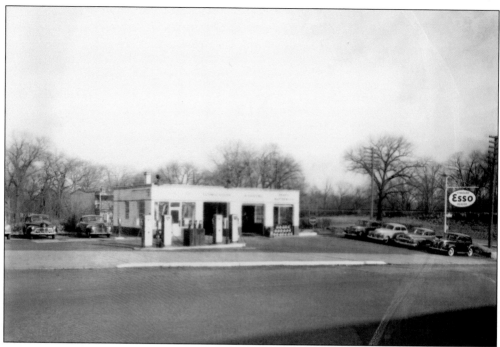

By World War II, the Hartmann and Fehrenbach Brewery was long closed. The majority of the buildings once contained within the three-acre complex were dismantled. In their stead were constructed houses, a trucking company, and this Esso gasoline pump and service station above. In this c. 1946 image, the station was owned and operated by Charles Carr. Today the station no longer pumps gas, but it is still a quality garage for automobile service and repair (below). (Courtesy of the Delaware Historical Society and private collection.)

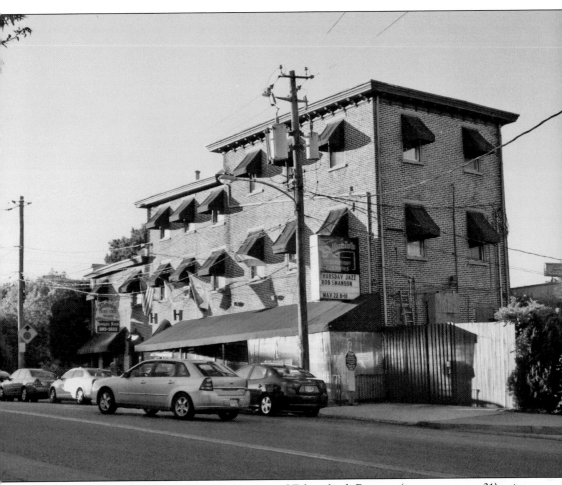

The last remaining buildings of the Hartmann and Fehrenbach Brewery (as seen on page 31) exist today as Gallucio's Italian restaurant and neighborhood bar. Previously known as the Embassy, it was purchased by Jerry Gallucio in December 1970 and continues today as a popular restaurant. (Courtesy of author.)

The neighborhood streetscape has changed little over the years. For the most part, the sidewalks are still paved with bricks in a variety of patterns, the most popular being a herringbone design. The majority of the housing stock reflects Italianate architecture, having the features of tall, narrow windows and doors with facades capped by overhanging cornices. These photographs give a proper illustration of the streetscape and housing styles. Above, Francis and Julie Kaiser pose for a father-daughter photograph with Nellie Chambers's "Flying A" gas station in the background, and below, Francis "Woody" Kaiser sits on a car on west side of 1900 block North Scott Street. (Courtesy of Cissy Kaiser Briggs.)

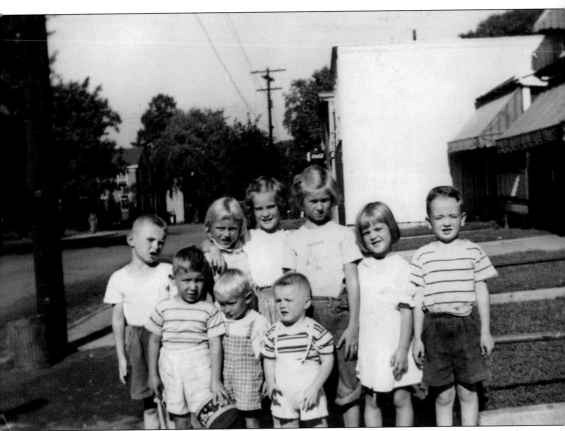

A group of childhood friends calling themselves the Lincoln Street Club gather on the east side of the 1900 block of Lincoln Street. They are, from left to right, (first row) ? Bromwell (holding hat), Jay Reed, and Edward Horgan; (second row) Joseph Horgan, Susan Reed, Jacqueline Steptoe, Jean Blakeley, Mary Jean Steptoe, and unidentified. (Courtesy of Jackie Walls.)

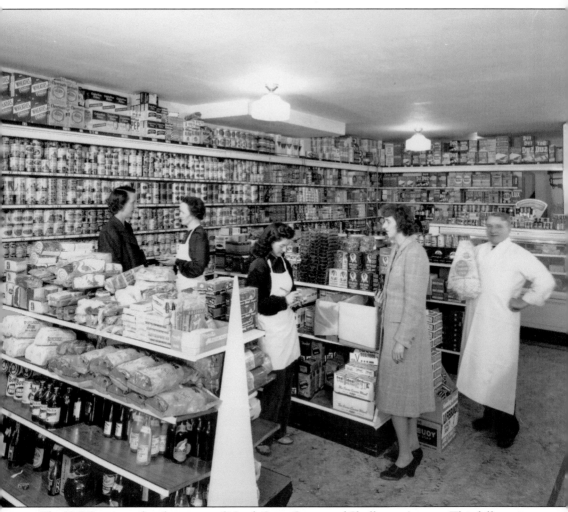

The J&S Store stood at the corner of North Scott Street and Shallcross Avenue. This full-service grocery store and butcher counter was owned and operated by Samuel Levin. This *c*. 1943 picture illustrates the interior of the store, where customers always received the very best service and attention. (Courtesy of the Delaware Historical Society.)

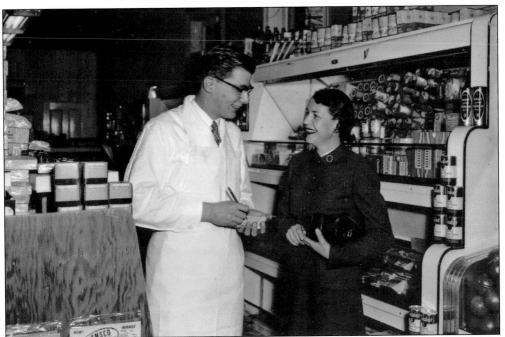

Interior images taken around 1950 illustrate Harry Levin assisting customers. Harry worked in his father's store before opening his own pharmacy and general goods store simply called Discount Center. He was quickly dubbed "Happy" by his patrons due to his friendly and congenial disposition. Harry eventually expanded his stores and renamed his company Happy Harry's Discount Drugs. (Courtesy of the Delaware Historical Society.)

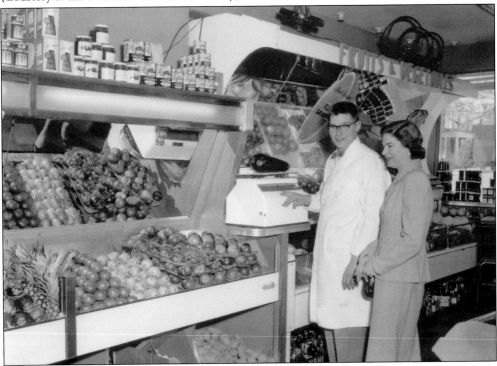

By the 1960s, the J&S Store became home to the Stapler Athletic Association. The club is an Irish American fraternal organization whose membership is composed mainly of men from in and around the Forty Acres neighborhood. At the start of every summer, the Stapler Club hosts a block party. The men of this club are fiercely proud of their Irish heritage and participate in the yearly Irish Culture Club of Delaware's St. Patrick's Day parade. Here members of Stapler Athletic Association follow St. Patrick in a parade down King Street. (Courtesy of private collection.)

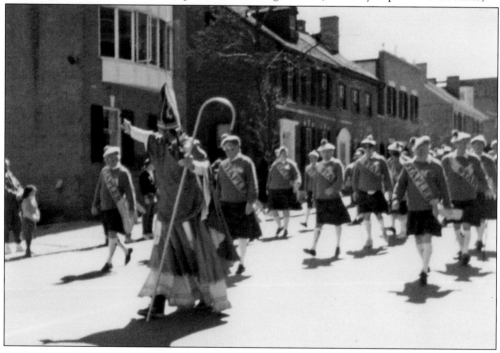

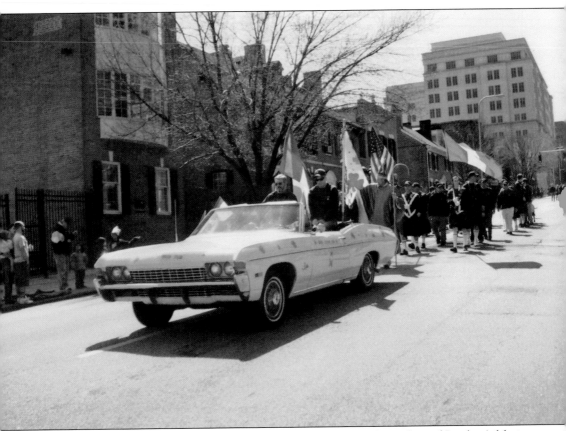

In a more recent St. Patrick's Day parade photograph, dating to 2005, members of Stapler Athletic Association are easily recognized in their kilts as they march in the annual parade. (Courtesy of private collection.)

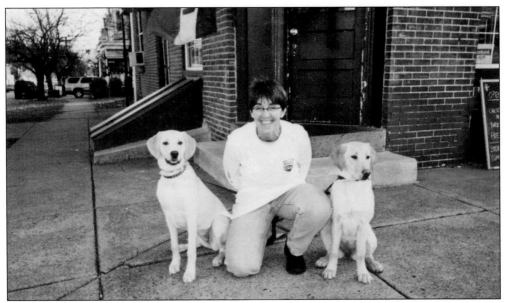

On the northeast corner of Lincoln Street at Shallcross Avenue is a corner restaurant once known as Sophie's Submarine Sandwich Shop. This store at 1836 Lincoln Street was originally owned by Sappho "Sophie" Constantinou and her husband, John. By 1940, the couple brought their son George into the business, and all three became equal partners. While many still fondly remember this restaurant as Sophie's, it is now known as Mary's Place, where many happy and lasting memories are made. Mary Austin continues the tradition of serving delicious meals with a warm smile, making all who enter her restaurant feel at home. Here Mary poses outside of her restaurant with two of her canine friends. Around the corner and down the street from Mary's Place once stood Laveechia's Bakery at the corner of Gilpin Avenue and North Scott Street. Young Hugh Callahan stands outside the bakery in the spring of 1967. (Above, courtesy of Mary Austin; below, courtesy of private collection.)

The Lincoln Pharmacy had two locations: 1330 Washington Street and Delaware Avenue at Lincoln Street. The latter location in Forty Acres was the larger of the two stores. This store had a soda counter and was well known for its chocolate cokes and milk shakes. (Right, courtesy of Jackie Walls; below, courtesy of Delaware Historical Society.)

A Handy CALENDAR for 1946 with SPECIAL DATES to REMEMBER

Tuck me in your pocket or purse

LINCOLN PHARMACY, INC.
1901 DELAWARE AVENUE

·LINCOLN SERVICE STORE
14TH AND WASHINGTON STREETS
WILMINGTON, DELAWARE

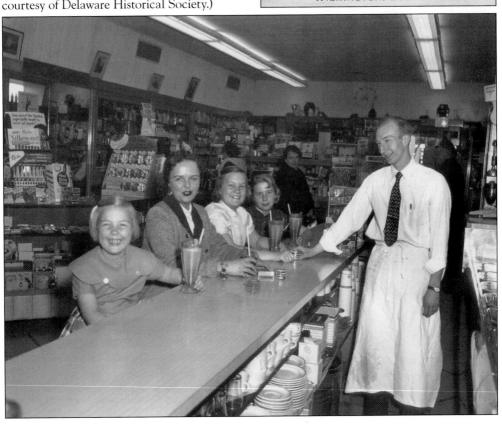

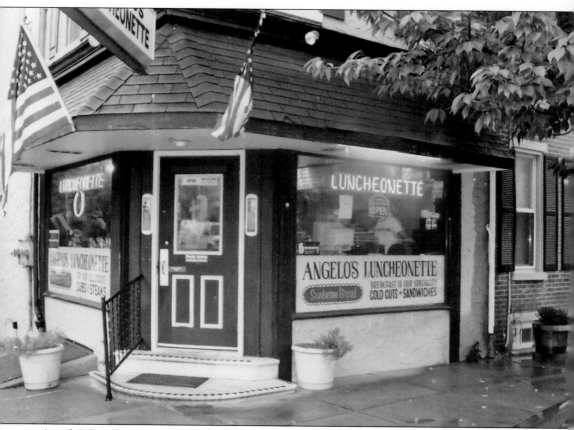

Angelo's Luncheonette was located at 1722 North Scott Street on the corner of North Scott Street and Gilpin Avenue. August Muzzi and his father worked as barbers in North Wilmington. Muzzi's father, originally from Rome, dreamt of opening a store much like the deli he owned in Italy. One day, a customer came into the barbershop and told the father and son of a luncheonette for sale in the Forty Acres neighborhood. That spring day in 1967 they not only went to look at Pantano's luncheonette, but they bought it. From that day, the corner store at North Scott Street and Gilpin Avenue became known as Angelo's Luncheonette and as the hub of the neighborhood. (Courtesy of author.)

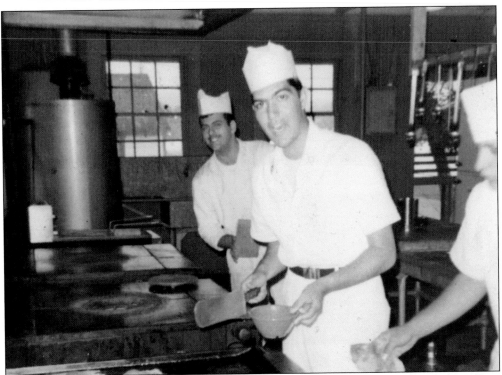

Two years after entering into a part-ownership agreement of the luncheonette with his father, August (above center) entered the army. Uncle Sam quickly recognized this young man's culinary talents and assigned him kitchen duty. Seen above in 1969, it is clear that Muzzi is no stranger to the grill! The luncheonette has entered into its third generation of ownership in the Muzzi family. Pictured below are, from left to right, (standing behind the counter) Theresa "Terry," Damian, and August Muzzi; (sitting) Michael Shaw, Kathryn Turner, Jessie Adkins, and Chris Cromer. (Above, courtesy of August Muzzi; below, courtesy of the author.)

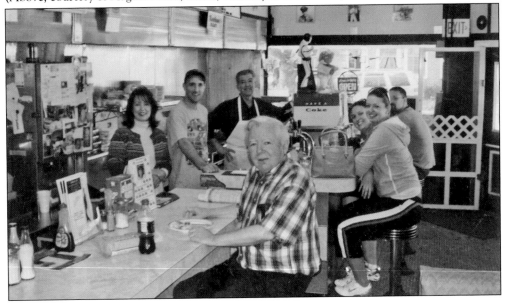

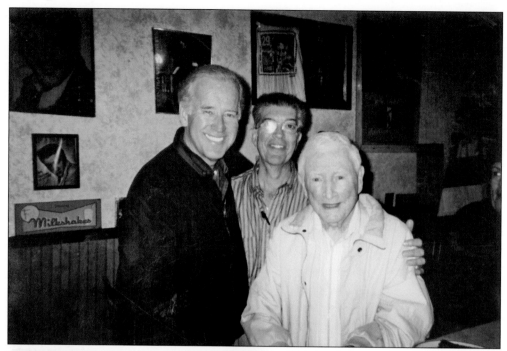

This luncheonette is part of the fabric of the neighborhood. It is the place to go not only for a great meal but also to learn of the goings-on of the neighborhood. Angelo's Luncheonette represents a place where people can connect with one another, touch base with one another, and confirm community in the neighborhood. As more than one patron has remarked, "Angelo's is like that Cheers place, where everybody knows your name." From left to right above are Sen. Joseph Biden, August Muzzi, and former Mayor William T. "Bill" McLaughlin. At left is former Mayor William T. "Bill" McLaughlin with Joseph DiPinto, who was then in the Delaware House of Representatives for the 4th District. (Both courtesy of August Muzzi.)

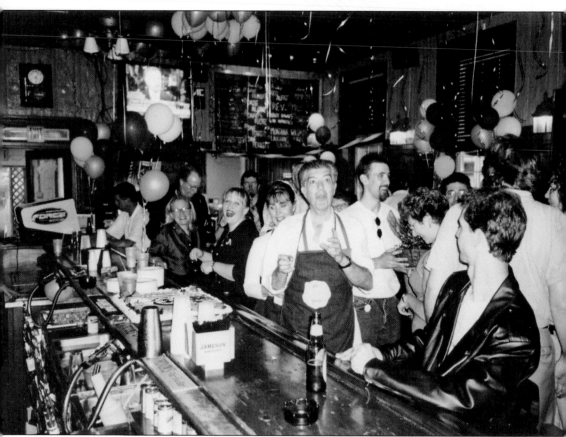

As more than one customer has remarked of the luncheonette: "Angelo's is uncharacteristic of anywhere else in Wilmington. When you come here, you leave the hustle and bustle behind. You talk to people. It's like walking into somebody's kitchen, where that relationship between families and friends is celebrated." It is so loved by the neighborhood that on the 35th anniversary of its opening, the owners were surprised with a party at Kelly's Logan House. (Courtesy of August Muzzi.)

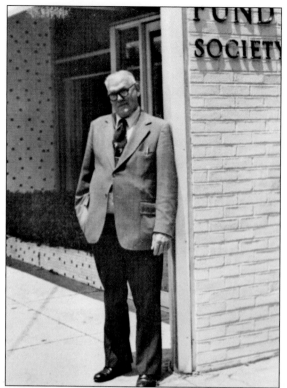

Another well-known person in the neighborhood was Charles Kaiser. Here he is pictured outside the Wilmington Savings Fund Society (WSFS) bank (above) on Delaware Avenue. Kaiser, given the nickname "the Mayor of Forty Acres" by bank employees and neighborhood residents alike, made people feel special by keeping up to date on the births, deaths, and anniversaries of all the bank's customers. Kaiser often assisted operating the pumps at the Lynum gas station before starting work at WSFS to simply give a hand. In the photograph below, he stands with Jack Lynum alongside one of the gas pumps. After work during the spring and summer months, he helped the elderly by mowing no less than six lawns a week. In winter he was known to keep the sidewalks of his neighbors clear by shoveling snow. He was often known to say, "If you can't do some good, you're in bad shape." (Courtesy of private collection.)

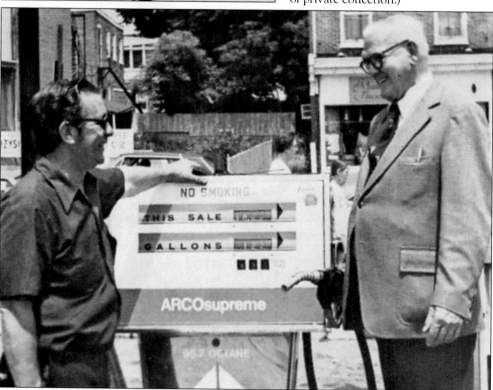

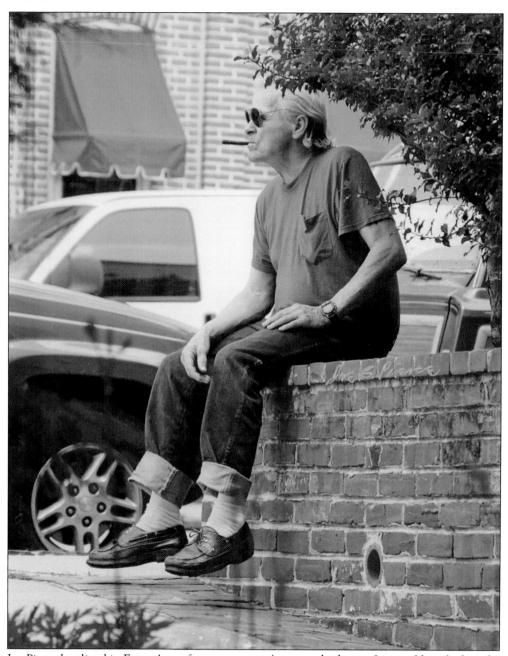
Joe Pierce has lived in Forty Acres for many years. Anyone who knows Joe would easily describe him as a happy-go-lucky person who would gladly give the shirt off his back if needed. He is known as someone who is willing to lend a hand and help out his neighbors with anything. Joe is a kind man who always has a "hello" for those he meets, and he is easily recognized in his casual attire of cuffed jeans and a cotton T-shirt. He is never without his trademark cigar. (Courtesy of Damian Muzzi.)

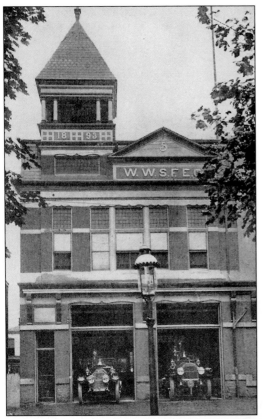

On March 13, 1833, the Water Witch Fire Company No. 5 was established with 30 members. It was the sixth fire company to form in Wilmington and had two locations before finally settling on its present location in Forty Acres. On April 12, 1893, the fire company was reincorporated as the Water Witch Steam Engine Fire Company No. 5. Members moved into a new three-story firehouse at 1814 Gilpin Avenue on December 12, 1893. Today the facade of the firehouse looks little different from its original construction; one exception is the missing bell tower. In October 1954, high winds from Hurricane Hazel brought the tower down. (Left, courtesy of Wilmington Fire Department and John Porter; below, courtesy of the author.)

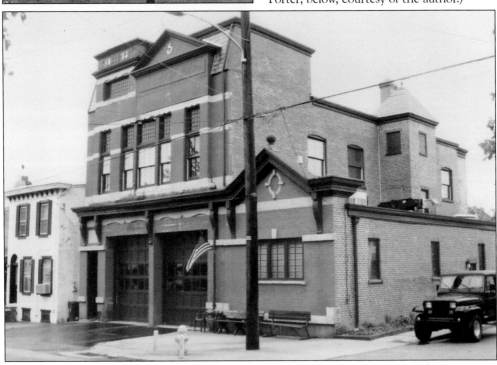

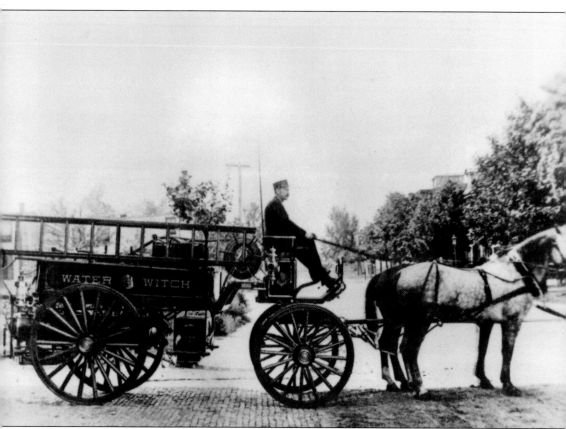

Tragedy struck the Water Witch on December 26, 1902, when members responded to an alarm at Eighth and Adams Streets. The chemical wagon, driven by Patrick Dougherty with John H. Maxwell, slid on the ice while turning the corner of Park Place and Van Buren Street. The chemical wagon was upset, and both men were thrown to the ground. Patrick Dougherty later succumbed to injuries received on March 21, 1904, making him the first paid Wilmington firefighter to die in the line of duty. (Courtesy of Wilmington Fire Department/the Water Witch, Fire Station No. 5 Archives.)

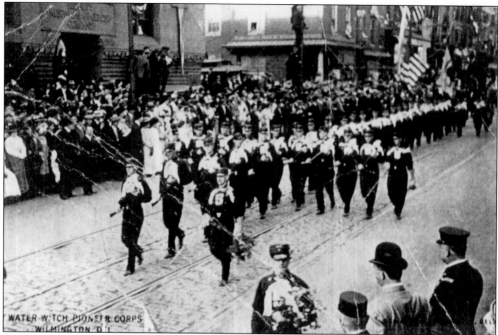

In 1921, the company's name changed once more from the Water Witch Engine House when the officers and members of the new paid Wilmington Bureau of Fire took over the operations. The company then became known as Fire Station No. 5. The company purchased two motorized pieces in 1910, and by July 8, 1911, they were fully motorized. No. 5 has always been a celebrated company. These images depict No. 5's Water Witch Pioneer Corps (above, c. 1910) parading on Market Street in Wilmington as well as posing with a new fire truck (below, c. 1923). (Courtesy of Wilmington Fire Department/the Water Witch, Fire Station No. 5 Archives.)

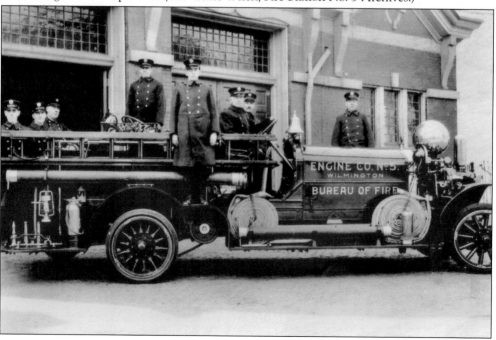

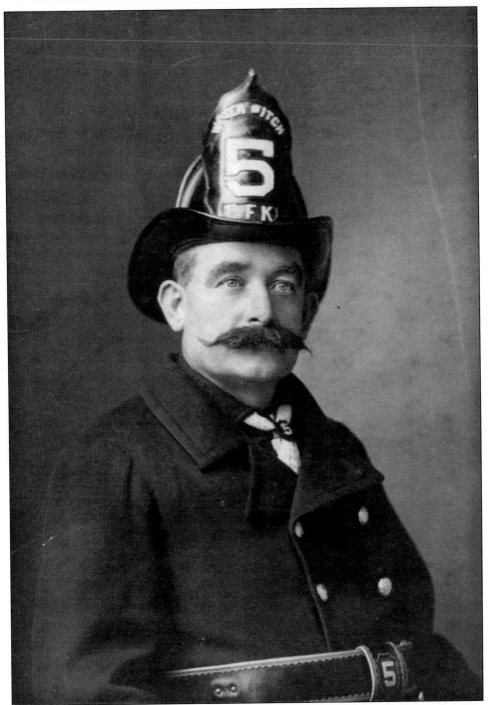

Firemen are usually held in high esteem for their bravery and heroism, and the people of Forty Acres are proud of the firemen who serve at Station No. 5. The dedication and courage that all firefighters demonstrate on a daily basis is truly humbling. This photograph is of an unidentified Water Witch firefighter, taken in the first quarter of the 20th century. (Courtesy of Wilmington Fire Department/the Water Witch, Fire Station No. 5 Archives.)

They are called upon to face fires burning terrifyingly out of control. They act as medical units as well, coming to one's aid when in the most need. They are the ones called to run inside burning buildings and houses. They are the ones called to face the blazing inferno. Citizens' lives and safety depend upon their bravery, skill, and professionalism. Members of Station No. 5 answer a call to put out a Gilpin Avenue house fire around 1989. (Both courtesy of James Kaiser.)

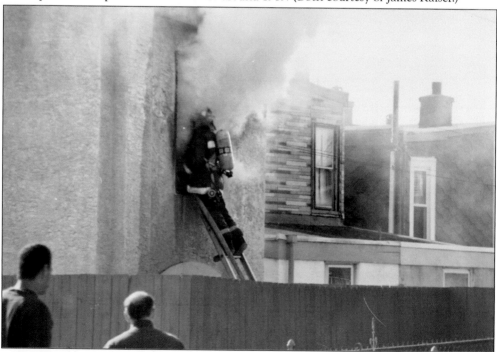

Katherine Gallagher is pictured at right in front of the firehouse in August 1960. Below, from left to right, are Marie Tharan and Kathleen and Eileen Quillivan, with Susan Lilly at the front center. (Courtesy of Cecilia Gallagher.)

Michael Gallagher is pictured on Lincoln Street. Behind him are, from left to right, Pini's candy store and a three-story apartment building known as the "White Elephant." (Courtesy of Cecilia Gallagher.)

Joseph Gallagher stands in the street at the 1700 block of Lincoln Street. The photograph allows for a nearly panoramic view of the block. Pictured are Ward's liquor store, Horisk's butcher shop, Doherty's funeral home, and Grace's candy store. With so many stores dotted between the houses on this end of Lincoln Street, it would seem there was always plenty to see and do. (Courtesy of Cecilia Gallagher.)

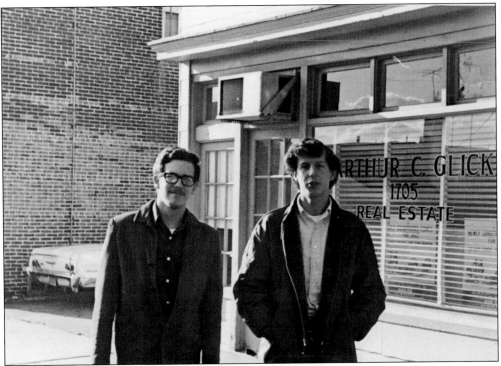

Standing outside of the real estate office are Dan Seal (left) and Thomas "Tommy" Cassidy. The two became friends while playing softball for the Stapler Athletic Association. (Courtesy of Cecilia Gallagher.)

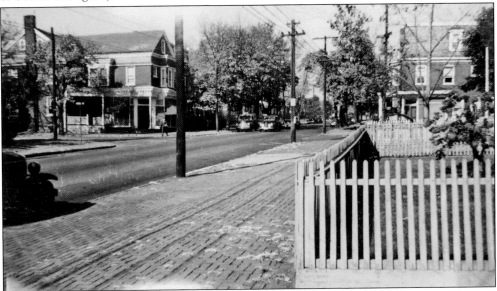

The intersection of Delaware Avenue and North Scott Street has not changed dramatically since this photograph was taken in the second quarter of the 20th century. The view looks west up Delaware Avenue towards North Scott Street. The picket fence visible on the right side of the image is at the yard of Mr. Haley. Haley operated a barbershop out of what is today a bar called Scratch Macgoos. (Courtesy of Ober R. Kline.)

The three-story brick building at the corner of North Scott Street and Delaware Avenue is celebrated in a number of paintings and drawings by artists such as Bayard Berndt and Jeanette Slocumb Edwards. This building (at left) has lived its life as the Noonan Brothers Hardware and Sporting Goods store and as Chapman's hardware store. For the past 30-plus years, the store below has been home to the Ober R. Kline frame shop. (Courtesy of Ober R. Kline.)

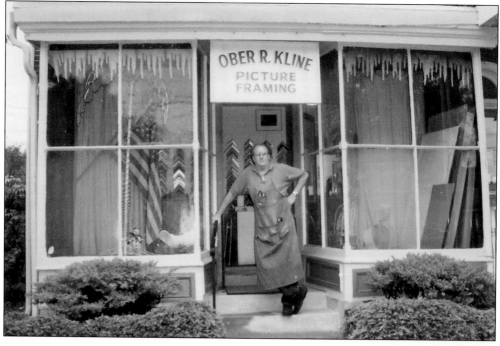

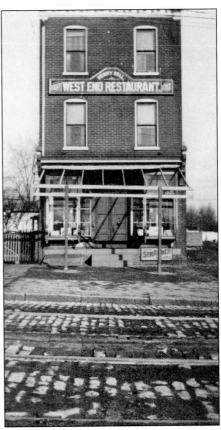

For other buildings in the neighborhood, there are a few facade changes, but the original usage remains the same. Such is true of the three-story Italianate restaurant located at the center of the block and on the north side of Delaware Avenue. In 1900, the restaurant was known as the West End; today it is simply known by its street address of 1717. (Right, courtesy of Ober R. Kline; below, courtesy of the author.)

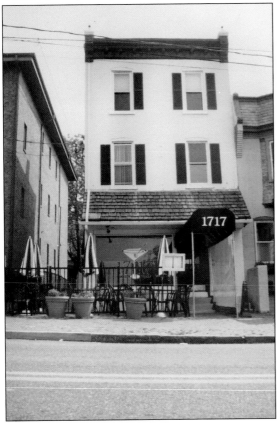

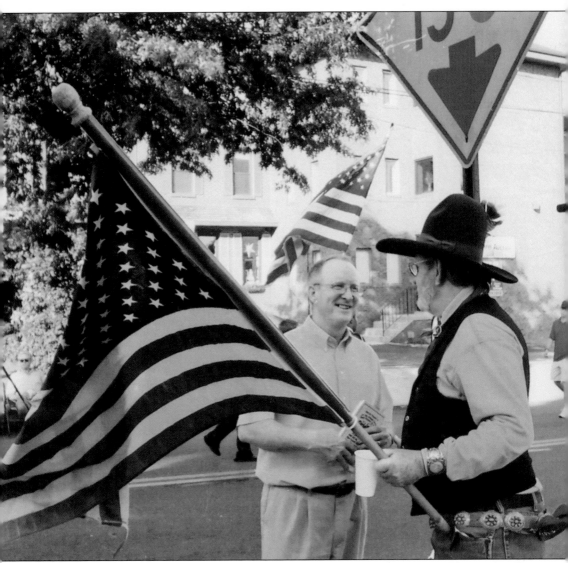

For over 140 years, Delaware has observed Memorial Day with a ceremony and a parade. The tradition began in 1868, when a group of New Castle County citizens formed a Memorial Day committee to honor those who died in the Civil War. On May .30, every year since 1868, the parade lines up 5:15 p.m. and steps off at 6:00 p.m. from Delaware Avenue at Woodlawn Avenue. Participants march east down Delaware Avenue to the Civil War monument at Broom Street, where the parade committee and its participants honor the dead of all wars with a memorial service. At the 140th Wilmington Memorial Day Observance and Parade in 2007, Gerald L. Brady (Delaware House of Representatives for the 4th District) pauses from marching in the parade to speak with Forty Acres' own resident cowboy, Ober "Obie" Kline. (Courtesy of private collection.)

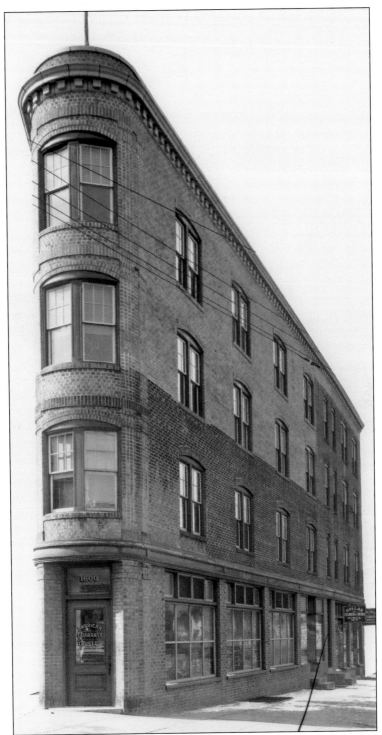

The four-story triangle building located at 1600 Delaware Avenue is one of two located in Wilmington, Delaware. This architecturally unique building serves as a visual marker for the eastern entrance into the Forty Acres neighborhood. (Courtesy of the Delaware Historical Society.)

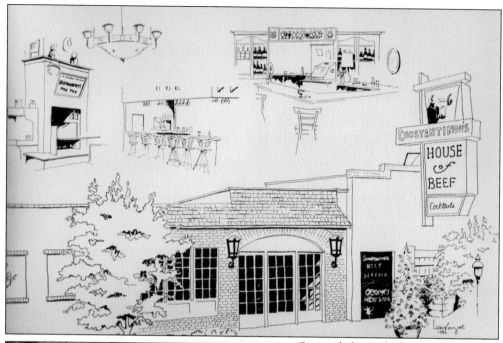

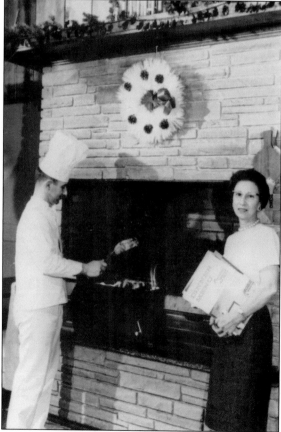

Situated alongside the triangle building was once the B&O lunch counter, owned by George Constantinou and his father. By 1959, after the passing of his father, George, along with his mother, Sappho "Sophie" Constantinou, took ownership of the restaurant and changed its name to Constantinou's House of Beef. The restaurant was a landmark in the neighborhood, renowned for fine dining and elegant atmosphere. George commissioned artist William Renzulli to sketch his restaurant's fine points. (Courtesy of George Constantinou.)

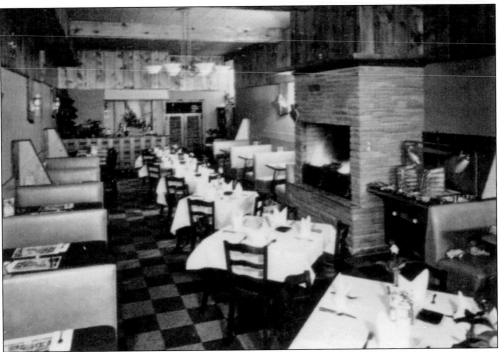

George Constantinou took great joy in cooking for his customers. With love and excitement, George charcoal-broiled choice aged prime ribs and steaks prepared in the open-hearth broiler at the center of the dining room, thus allowing customers to watch their meal prepared in meticulous surroundings second only to the Hotel DuPont. Constantinou's elegant restaurant was handsomely decorated with electrified gasoliers, nine eagles from the original John Wanamaker's in Philadelphia, and completely restored rose-colored pocket glass doors. He paid meticulous attention to detail in every design characteristic of his restaurant's interior. (Courtesy of George Constantinou.)

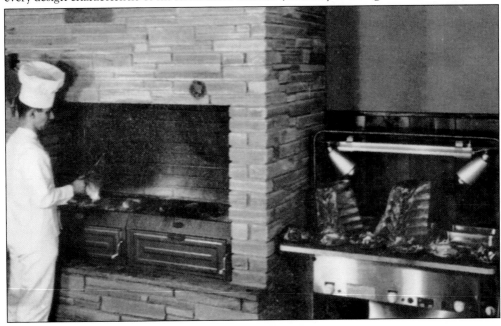

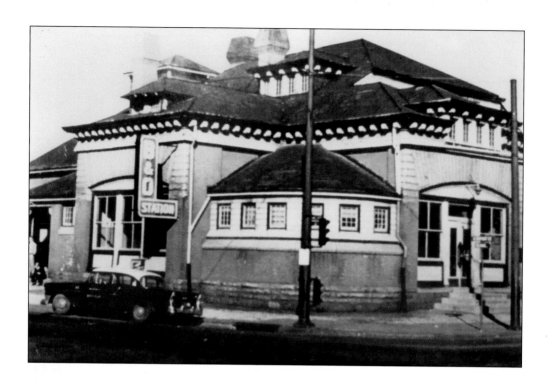

The B&O passenger railway station was constructed on the northwest corner of Delaware Avenue and DuPont Street in 1884. The ornate Victorian building was used as a place to catch a train for a trip away from home and was also a place to gather, hangout, and people watch. (Above courtesy of the Delaware Historical Society; below courtesy of Jackie Walls.)

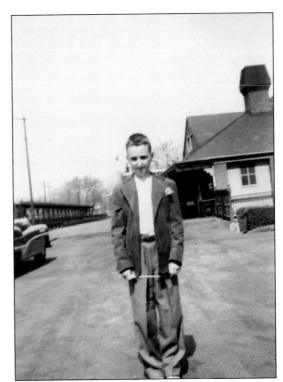

William "Billy" Briggs III, with rosary in hand, waits on the upper platform of the B&O station before embarking on a St. Anne's School field trip to Washington, D.C. Below, this late-19th or early-20th-century image of the B&O station gives a better sense of the upper platform. (Right, courtesy of William J. Briggs III; below, courtesy of Delaware Historical Society.)

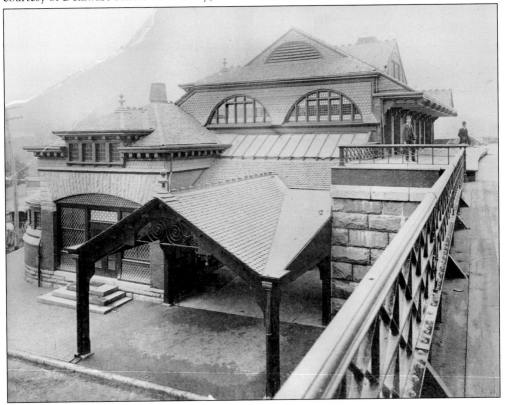

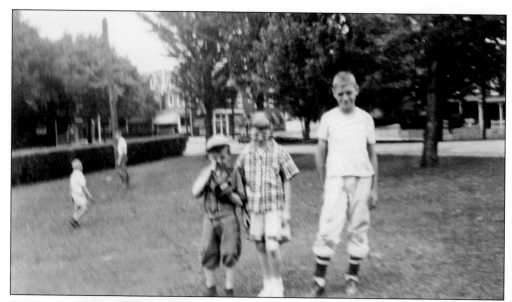

One of the nearest places for a child to run and play in Forty Acres was the park adjacent to the B&O Railroad station. Although this area is now home to a car dealership detailing office, the once-grassy field was situated on the west side of the B&O station at the northern side of Delaware Avenue. It was a nice place to either pose for a family picture, as the Schofield children are seen doing here, or to take a quick snap shot between innings of a game of baseball. (Both courtesy of Paul M. Schofield Sr.)

Another view of the grassy B&O park area is seen across Delaware Avenue over the shoulder of this beautiful child. (Courtesy of Paul M. Schofield Sr.)

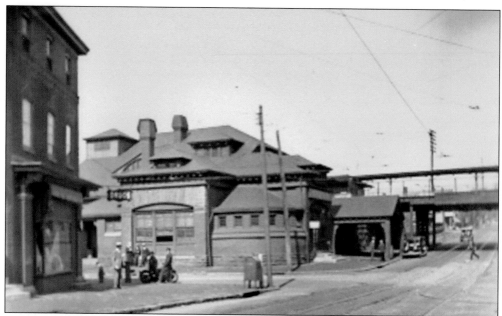

Delaware Avenue is pictured looking west to DuPont Street. On the left side of the street from left to right are Cappeau's Drug Store, the B&O Railroad station, and the B&O Railroad bridge. Cappeau's was a neighborhood drugstore and soda counter where young people would happily gather after school to talk about the goings-on of the day over root beer floats. (Both courtesy of the Delaware Historical Society.)

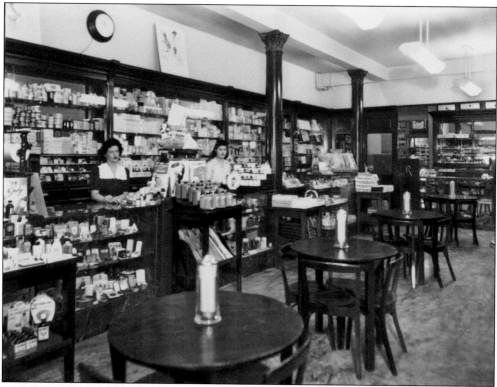

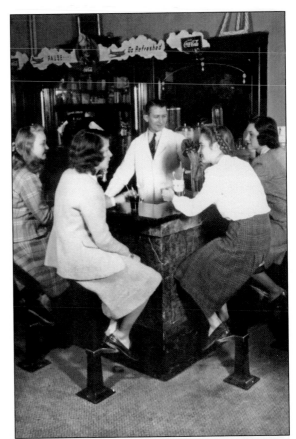

Inside Cappeau's Drug Store, a group of young ladies enjoys an afternoon chat at the counter while drinking cold and delicious soda fountain drinks served by Thomas Cappeau. In the meantime, a group of young people (below) enjoys their drinks sitting around a table. (Both courtesy of the Delaware Historical Society.)

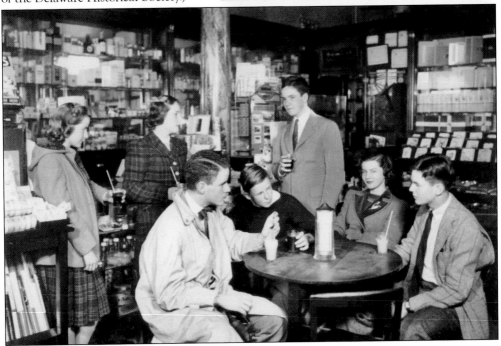

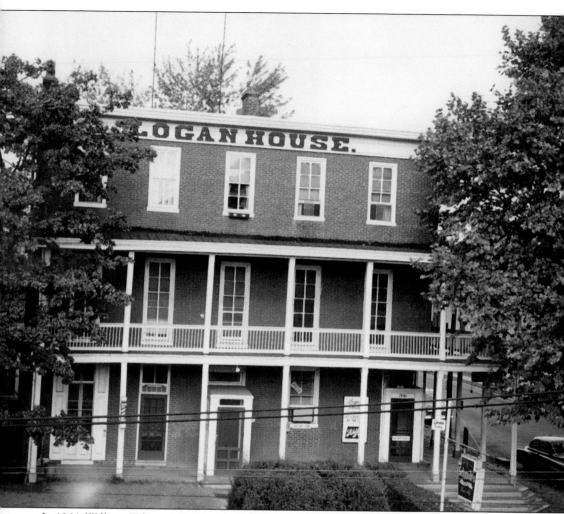

In 1864, William Wharton Jr. constructed a hotel across the street from the carbarns at the corner of Dupont Street and Delaware Avenue. Wharton named his hotel the Logan House after Civil War hero Gen. John Logan. The hotel maintained a tavern on the first floor and rented rooms on the second and third floors. In later years, the hotel and taproom also maintained a barbershop in a room on its ground floor (lower left of the building). Note the iconic pole at left. (Courtesy of the Delaware Historical Society.)

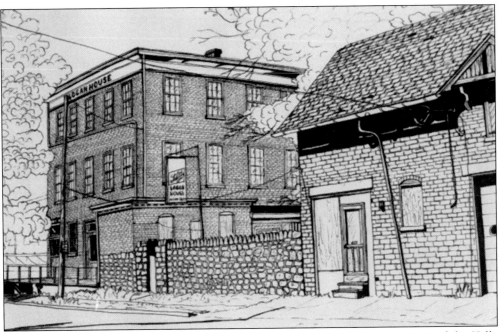

Ownership of this popular city bar and nightspot has passed through generations of the Kelly family since it was first purchased by family patriarch John D. Kelly II in 1889. Generations of Kelly family members have promoted this neighborhood bar as a center for Irish social and cultural life. Countless drawings, paintings, and photographs of the Logan House, as well as newspaper and magazine articles, are testament to the love Wilmingtonians have for this longtime Forty Acres institution. (Above, courtesy of the Delaware Historical Society; below, courtesy of the author.)

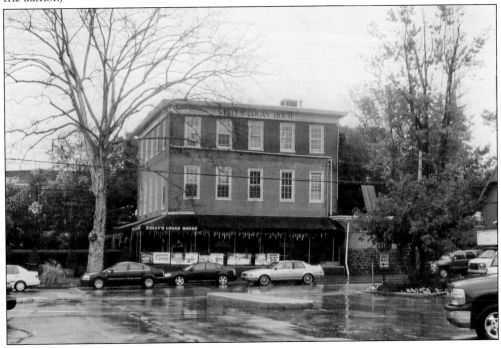

Florence Elizabeth "Flo" Danko, worked in the cafeteria at Salesianum High School from 1964 until her retirement in 1992. As this photograph taken at a Salesianum basketball game illustrates, she dearly loved this high school and attended every school activity. Florence loved music and enjoyed sitting on her front porch to play her favorite tune, "The Blue Dress Polka," on her accordion. A kind-hearted soul, she would go out of her way to make someone smile and truly brought joy to each and every life that she touched. (Above, courtesy of August Muzzi; below, courtesy of Robert Keller.)

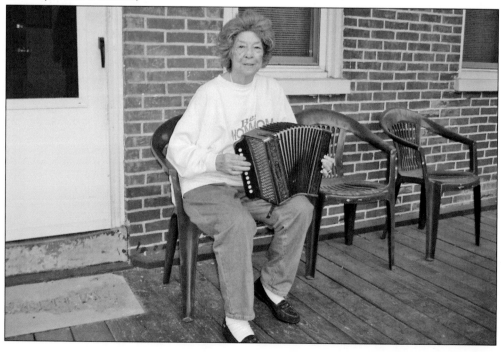

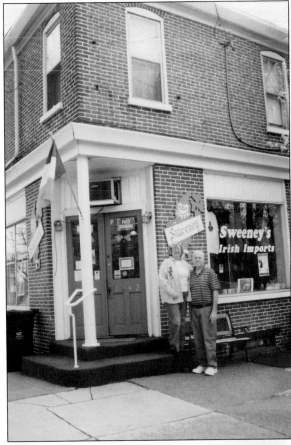

This corner store at Gilpin and Union Streets is remembered fondly as a variety of businesses throughout the history of Forty Acres, including a sandwich shop, one of the last location's of Horisk's candy shop, and a bookstore. Since 1995, this small shop is host to Sweeney's Irish Imports. It is the only Irish shop in northern Delaware and has found tremendous success in Forty Acres, which is considered by the current owners to still be about 80 percent Irish. Sweeney's is owned and operated by Leo John and Eileen (née Claffey) Sweeney. (Courtesy of the author.)

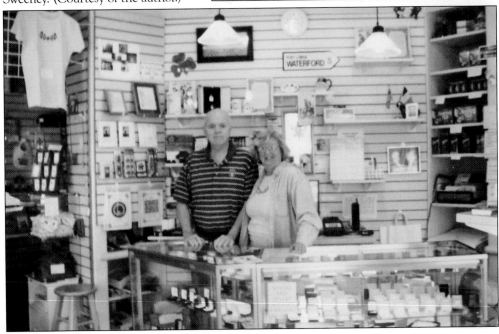

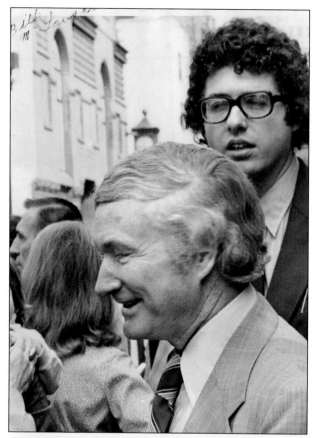

At left, William T. "Bill" McLaughlin is pictured with fellow Forty Acres native John Flaherty in July 1976. Bill McLaughlin was born in the Forty Acres neighborhood but grew up on the east side of Wilmington. McLaughlin was mayor of Wilmington from 1977 until 1985. When elected to office, his first initiative was to revitalize the Forty Acres neighborhood by developing the old carbarn site. John Flaherty remembers former Mayor Bill McLaughlin as a mentor and friend but above all a good and decent man. As a mentor, Bill McLaughlin and his late wife, Mary, helped John become involved in Democratic politics in the early 1970s. In 1976, when McLaughlin ran for his first term as mayor of Wilmington, Flaherty served as his campaign coordinator. From left to right below, John Flaherty poses with Bill McLaughlin in the 1970s. (Courtesy of August and Damian Muzzi.)

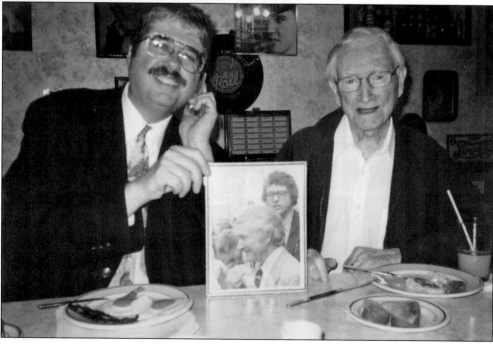

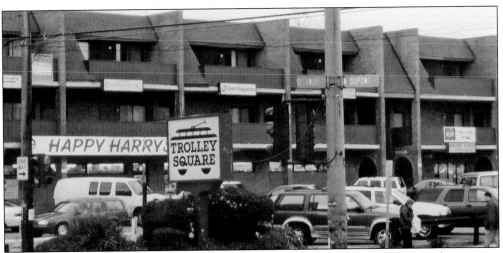

In 1978, Mayor McLaughlin's dream of revitalizing the Forty Acres neighborhood came to a reality. The old carbarn site, reduced to an empty lot and used as makeshift parking by patrons of both Constantinou's House of Beef and Kelly's Logan House, became the heart of McLaughlin's revitalization effort. McLaughlin recognized that the old carbarn site had been left abandoned for too long and decided, "We have to find something to do with this." Based on a series of studies initiated by Mayor McLaughlin's office, it was determined that a shopping center was best suited as a way to stabilize the neighborhood economy. McLaughlin held fond memories of the Wilmington trolleys and saw the opportunity to develop the carbarn site while paying homage to the old trolley cars. When construction of the shopping center was complete, it was named Trolley Square. Many have come to associate the Forty Acres neighborhood with the Trolley Square shopping center. Fearing a loss of identity, Forty Acres residents put into action a series of schemes to save their neighborhood. One was to establish Forty Acres as the state of Delaware's first Neighborhood Conservation District. For the residents of this small urban area and for the people who love it, the neighborhood will always be Forty Acres. (Courtesy of private collection.)

BIBLIOGRAPHY

PRIMARY SOURCES

Account Book of Joseph S. Lovering: Joseph S. Lovering Collection [#1789], "Hope Farm" Account
 Book, 1860–1868 [D-104]. The Historical Society of Pennsylvania, Philadelphia.
Christiana Hundred Tax Assessment Records, 1816.

SECONDARY SOURCES

Barnard, Mary Ann. A History of Forty Acres to 1910: Myth and Reality in a Wilmington, Delaware
 Neighborhood. Thesis submitted to the faculty of the University of Delaware in partial fulfillment
 of the requirements for the degree of Master of Arts in History, June 1981. Morris Library,
 University of Delaware, Newark.
Calvert, Monte A. The Wilmington Board of Trade, 1867–1875. Delaware History 12. Wilmington, DE:
 The Historical Society of Delaware, 1966–1967.
Canby, Henry Seidel. The Age of Confidence. New York: Farrar and Rinehart, 1934.
Cox, Harold E. Diamond State Trolleys, Electric Railways of Delaware. Forty Fort, PA: Harold E.
 Cox, 1991.
Delaware Department of Transportation. Transitioning to Transit: Delaware's Long Range Transit
 Plan for the 21st Century, Long Range Plan Highlights 2000–2025. Delaware: Delaware Department
 of Transportation, 2000.
Downs, Anthony. Neighborhoods and Urban Development. Washington, D.C.: Brookings Institution,
 1981.
Gans, Herbert J. The Urban Villagers: Group and Class in the Life of Italian-Americans. Updated
 and Expanded Edition. New York: The Free Press/Simon & Schuster, Inc., 1982.
Gibb, Hugh R. The Wilmington and Western Railroad Company, The Bulletin of the National Railway
 Historical Society.
Grier, A. O. H. This Was Wilmington. Wilmington: The News-Journal, 1945.
Historical Review of the Volunteer Fireman's Relief Association. Wilmington: Mercantile Printing
 Company, 1920.
Hoffecker, Carol E. Corporate Capital Wilmington in the Twentieth Century. Philadelphia: Temple
 University Press, 1983.
———. Wilmington, Delaware Portrait of an Industrial City, 1830–1910. Charlottesville, VA:
 University Press of Virginia for the Eleutherian Mills-Hagley Foundation, 1974.
Hulse, Lamont J. West End Neighborhood House: 100 Years of Service. Wilmington: West End
 Neighborhood House, Inc., 1983.
Jacobs, Jane. The Death and Life of Great American Cities. New York: Random House, 1961.
Kurth, John. Background and Development History of the Forty Acres. Unpublished [2007.01.0001.01],
 the Center for Historic Architecture and Design, University of Delaware, Newark.
Lincoln, Anna T. Wilmington Delaware: Three Centuries Under Four Flags 1609–1937. Rutland, VT:
 The Turtle Publishing Company, Inc., 1937.

Mulrooney, Margaret M. *Black Powder, White Lace: The du Pont Irish and the Cultural Identity in Nineteenth-Century America*. Hanover, N.H.: University Press of New England, 2003.

One Hundred Years of Brewing: A Complete History of the Progress Made in the Art, Science and Industry of Brewing in the World, Particularly during the Nineteenth Century. Chicago and New York: H. S. Rich and Company, 1903.

Prentzel, John. *History of St. Ann's Church: 1887–1989*. Wilmington: McClafferty Printing Company, 1989.

Scharf, Thomas J. *History of Delaware, 1609–1888*. Volume Two.

Suarez, Ray. *The Old Neighborhood: What We Lost in the Great Suburban Migration: 1966–1999*. New York: The Free Press, 1999.

Warner, Sam Bass Jr. *Street Car Suburbs: The Process of Growth in Boston, 1870–1900*. Boston: Harvard College, 1978.

MAGAZINES/JOURNALS

Hess, Maria. "Next Stop: Trolley Square, A Great City Neighborhood that Keeps Getting Better," *Out & About Magazine*, May 2004.

"A Look Back at Trolley Square." *Delaware Today Magazine*, May 2004.

Medoff, Theresa Gawlas. "Neighborhood: Forty Acres." *AAA World*. March/April 2004.

McGivney, Bill. "Meatloaf for 400!!!" *News from the Pews: The Newsletter for the People of St. Ann Parish*. Winter 2000, 1.

Woods, Robert A. "The Neighborhood in Social Reconstruction." *American Journal of Sociology* 19 (March 1914), 577–591.

NEWSPAPERS

Miller, Jennifer M. "Trolley Square Fire Station to Become Museum." *Greenville Community News*, November 30, 1999, 10.

Shaw, Julie. "Irish American Families Grow in Delaware," *Spark: Ignite Your Life*, March 9, 2005, 14–15A.

Soulsman, Gary. "Necessity of Reinvention." *The News Journal*, Wilmington, November 19, 2001.

———. "Well-Rounded Trolley Square." *The News Journal*, Wilmington, February 17, 2003, Section E, 1–3.

DISCOVER THOUSANDS OF LOCAL HISTORY BOOKS FEATURING MILLIONS OF VINTAGE IMAGES

Arcadia Publishing, the leading local history publisher in the United States, is committed to making history accessible and meaningful through publishing books that celebrate and preserve the heritage of America's people and places.

Find more books like this at
www.arcadiapublishing.com

Search for your hometown history, your old stomping grounds, and even your favorite sports team.

Consistent with our mission to preserve history on a local level, this book was printed in South Carolina on American-made paper and manufactured entirely in the United States. Products carrying the accredited Forest Stewardship Council (FSC) label are printed on 100 percent FSC-certified paper.

MADE IN THE